DRAWING & PAINTING

expressive

··· LITTLE ···

FACES

DRAWING & PAINTING

expressive

···LITTLE···

FACES

Step-by-Step Techniques for Creating
People and Portraits with Personality

AMARILYS HENDERSON

QUARRY

Inspiring | Educating | Creating | Entertaining

Brimming with creative inspiration, how-to projects, and useful information to enrich your everyday life, Quarto Knows is a favorite destination for those pursuing their interests and passions. Visit our site and dig deeper with our books into your area of interest: Quarto Creates, Quarto Cooks, Quarto Homes, Quarto Lives, Quarto Drives, Quarto Explores, Quarto Gifts, or Quarto Kids.

First Published in 2020 by Quarry Books, an imprint of The Quarto Group,
100 Cummings Center, Suite 265-D, Beverly, MA 01915, USA.
T (978) 282-9590 F (978) 283-2742 QuartoKnows.com

Quarry Books titles are also available at discount for retail, wholesale, promotional, and bulk purchase. For details, contact the Special Sales Manager by email at specialsales@quarto.com or by mail at The Quarto Group, Attn: Special Sales Manager, 100 Cummings Center, Suite 265-D, Beverly, MA 01915, USA.

10 9 8 7 6 5 4 3 2 1

ISBN: 978-1-63159-865-4

Digital edition published in 2020
eISBN: 978-1-63159-866-1

Library of Congress Cataloging-in-Publication Datais available.

Design and Page Layout: Megan Jones Design
Photography: Amarilys Henderson; photography of Amarilys in her studio (pages 11 and 142)
© Betsy Wall Photography, www.betsywall.com; page 25, Shutterstock.

Printed in China

I Am a Little Lady children's book by Alexandra Tupy, shown in Chapters 1 and 15 www.littleladies.club

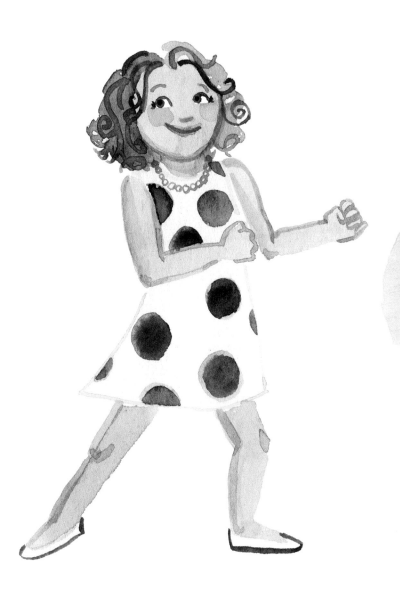

This book is dedicated to the faces around me that inspire me out of love.

And to the generous few who saw more than a little girl's scribbles and became my first patrons.

CONTENTS

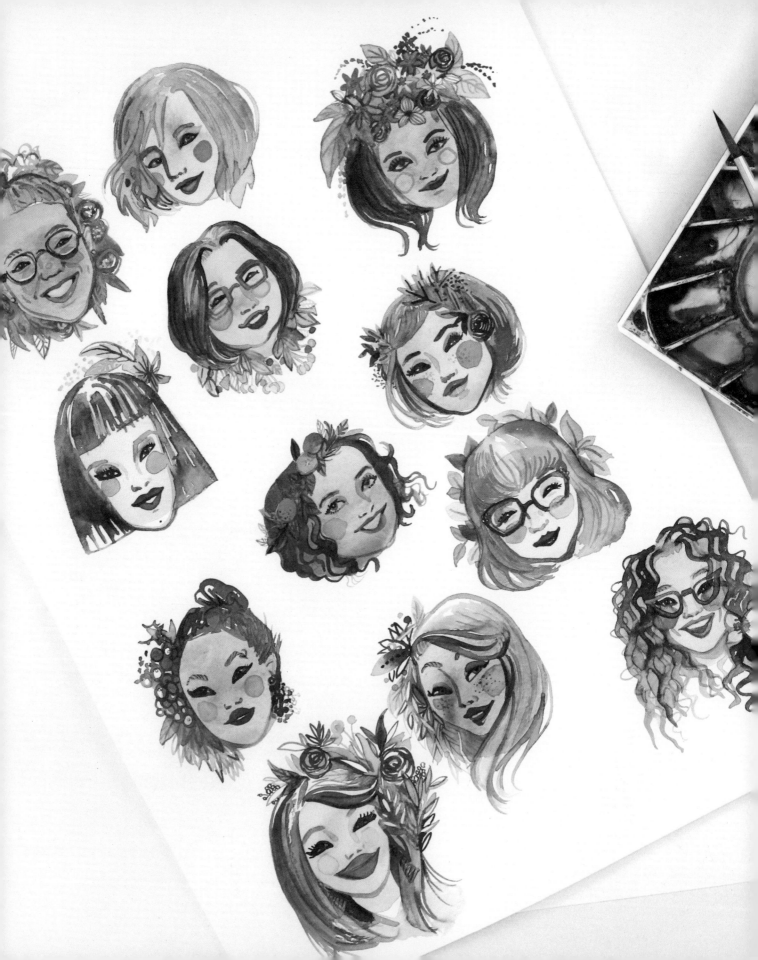

INTRODUCTION

I know why you picked up this book. Drawing faces is something so many of us long to do. It's a creative rite of passage, an artist's challenge to check off, and a handy skill to master all in one. Faces are something we look at from morning to night and often after bedtime. They're readable and relatable. They're special yet commonplace. Faces are the windows to who we are and the cues to how we feel.

Perhaps I'm biased. I was the little girl in school who was buried in her sketchbook. I even tried to sell them for millions of dollars at dinner parties. And although my graphic designer mother dismissed them at first as child's play, a schoolteacher showed her that not everyone in the class doodled faces on the daily. My mom saw potential beyond my *garabatos*, or scribbles, and so I dedicate this book to her. I also do this to make amends for the first portrait I proudly did of her . . . with black splatters that looked like mud splashed on her face—they were freckles.

I'm happy to report that I've grown out of painting freckles in black and have taken my kiddie drawings to a level where I help support my family with my brushstrokes. I paint art that's placed on products, books, and used in my online classes where I enjoy sharing my creative insights the way I wished someone would have shared with me. Demystifying faces has been a passion for me as I've wrestled with communicating human emotion and portraying peoples' diversity. I also love to tell a story with a face. It only takes a few subtle details to gain a sense of familiarity and catch a glimpse of personality.

THE APPROACH

A single face tells a story. Or rather, our stories are written on our faces. Most people may frown on reading a book by its cover, but it's a normal practice we all do to some extent. We begin understanding each other by looking into each other's eyes and thereby trying to discover the world outside ourselves. The questions we are going to ask ourselves as we draw faces have more to do with who this person we're creating or representing is than where the shadows fall on their facial planes.

You've likely seen the books or received instruction that teach the value of an onslaught of pencil lines, each calculating the distance and proportions of the features on a face—the subtle shading or tick marks, the meticulous detail, or softened edges that create a beautiful face. We call this portraiture. Portraiture aims to transfer the image of a person—however realistically or romanticized. Its concern is in the accurate telling of what this particular person looks like.

This book is not a book on portraiture. It is a book on faces. What's the difference? While portraits tell us what we see, faces can describe who the person is. We're not transferring colors and lines from reality to paper; we're translating the mood, features, and even dreams of the people

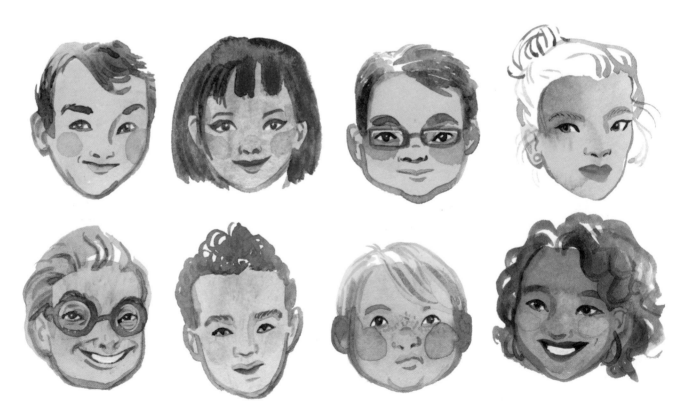

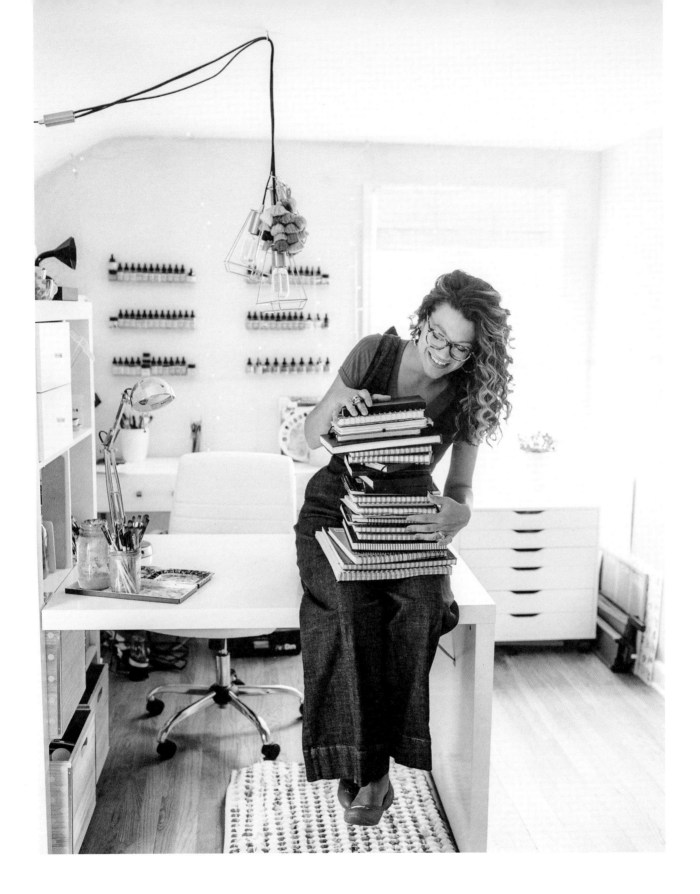

Painting

Since the approach to faces in this book is like adding layers and elements from a menu, creating with a layering method makes sense. Pencils are great for the start, but we'll drop them pretty quickly. Pencils encourage us to adjust—dare I say, obsess—and that's just no fun. We want to save our creative energy for asking "what about this?" questions as the piece progresses, not as we rethink what's already on the paper.

What I appreciate about painting in layers—beginning with light colors and broad strokes and ending with tiny details—is that we watch the subject emerge. Who doesn't love a good hyperlapse video on Instagram? It's like watching an object float up in the water, its characteristics becoming more pronounced as it reaches the surface. A light blob comes closer and closer until they can be enjoyed in high definition.

Other mediums will be introduced and used in this book, but you'll quickly see that my preferred medium is watercolor. It's translucent, it's fast, and it's accessible. My practical side is pleased that I don't have to squeeze tubes and clean up after use. I can make a color lighter or darker with water. Its semiopaque finish and the way that watercolor effortlessly blends into different shades and hues is very true to reality. An orange ball has flecks of yellow, red, and brown while shadows on a white wall often have violet, blue, and yellow. How much more profound are the colors of nature when created with deep complexity and texture?

we're drawing—both real and imagined. I named this book *Drawing and Painting Expressive Little Faces* because however wonky, strange, or disproportionate, these little faces hold their unique brand of charisma. You may feel like you know them!

So how will we go about making faces? We'll cover the basics you need to know to create a framework. We'll look at the basic proportions of the face, what's most important to include, and what to focus on. From there, we'll run head-long into questions that help describe who we're painting in order to define what kind of features and details we'd like to include on our face. It'll feel more like a build-your-own salad bar than being behind a chef's counter. After spending enough time putting ingredients together, you'll get faster, more creative, and begin to envision the final product without noticing that you're answering those questions almost instantly in the back of your mind.

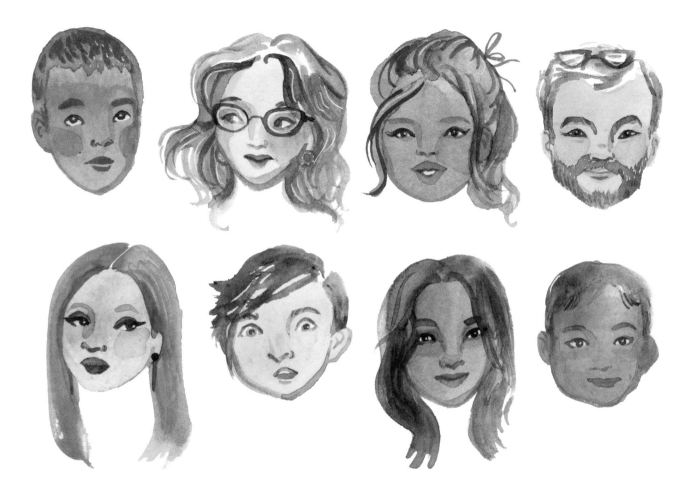

Before I end my flattery of the wonders of watercolor, I must add one more important feature I mentioned above: watercolor forces us to create fast work. With watercolor, we must work quickly to make decisions and commit to what's in front of us. What might sound like pressure is actually very freeing. This process will impart a pass or fail and then move on approach.

But I don't want you to set up camp at "good or bad." There is a shift in responsibility that needs to happen in creating if your goal is to not go mad. It is this: the piece plays a role, too. We tend to think that, as its creator, we are solely responsible for the outcome of a piece. I'd like to challenge that philosophy with the concept that we are conduits of creativity. I'll often look at a finished painting and think to myself, "so that's what it's supposed to be!" in amusement. The final work is often a surprise to me because the initial picture I had in my mind is not what's in front of me. Created works will live on, be interpreted by other eyes, replacing the rough draft I created in my mind. A birth is always full of surprises!

Take the pressure off. Your faces will be what they were destined to be all along, as long as you make them come into this world for all of us to enjoy!

Proportions

You need to learn your way around a face to make it all come together. We could get really technical on this one, but I'll just show you the bare basics. Am I stingy, holding back information? Nah, I just want to get you to your art supplies as quickly and as confidently as possible! You'll be surprised what a little knowledge of proportions can do to propel your originative brushstrokes.

True to this book's title, we keep our faces little. I find drawings often carry a weight of expectation as large as their canvas. Keeping the work small is an easy way to relieve pressure and dupe yourself into play mode. Play is critical to creativity. We are going to play at faces! As soon as you start thinking of having fun, your art will improve and you're much more receptive to learn from the principles in this book.

Personality

How can a little drawing pack personality? Our eyes take in a multitude of clues—colors, details, shapes, all of which we synthesis through "types." These may come from personal experiences or assumptions based on external cultural cues or stereotypes. Whatever the case may be, we ascribe attributes to people based on what we see. It's just human nature. And it's a basic survival trait we'll capitalize on for creative consumption.

We take the face piece by piece and ask questions about each feature as we choose what's next in developing the personality. The questions increase toward the end as we select possible accessories, facial hair, piercings, and other small elements that the person typically chooses themselves. These coupled with the subject's facial expression speak volumes toward a personality. If a picture speaks a thousand words, how much more can a painting constructed line by line communicate?

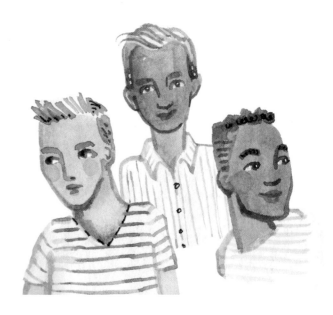

THE PORTFOLIO

As I mentioned, drawing people has always been important to me. I treat my sketchbook like a visual diary, marking my highlights and hopes. When I was younger, I'd draw pretty faces from magazines and boys offering Valentines chocolates to blushing girls. Sappy, yes, but it's also the kind of imagery that we eat up. I was picking up on what was popular, taking notes on what was most well-received, and telling mini stories in my drawings.

Illustration wasn't always my love. It was a close second to animation. But somewhere along the way, I became serious about how many iterations of the same person I wanted to work on. I found that I love variety, which I'm sure you've picked up on already. The faces I draw may not vary much in the way they're portrayed, but I do enjoy exploring different nuances in faces and different applications for these drawings.

I've been fortunate to make a career of my creating. The faces I've painted have peppered various surfaces as designs to cover everyday products as well as tell stories in illustrated books. Up your face game and increase the number of faces that resonate, either with your practice or your work.

I'm excited to draw back the curtain on the dozens or perhaps hundreds of little faces you're going to create after following along with this book. You'll see how painting is a fast way to create that naturally yields fabulous results and learn about basic proportions, understanding where to insert facial features from the myriad options on the map of the face. And your faces will beam a personality all their own with a few hints of details and clues into the persona behind the face. I can't wait to begin this journey with you!

ESSENTIAL SUPPLIES

Walking through the aisles of an art supply store is both invigorating and intimidating. Rows of colors fill my mind with possibilities while decision paralysis sets in as I see the variety of brands and price points for each item. I volley between what I need, what I think I need, and what I don't know I need.

This chapter serves as an overview of all the fun art supplies you'll see sprinkled throughout this book. Don't get overwhelmed; you don't need to make this your shopping list. I just want to provide you with information for when you're ready to get to work. I also offer my best practices as I select and use each medium.

WATERCOLORS

I have the same question whenever I look at paints: How saturated are the colors? This is not every artist's first question, though it is what is most important to me. I want each color I use to be rich and lush. Other factors that are important to artists are archival quality or viscosity (its texture or how well the paint flows through the brush). My favorite paints below demonstrate each of these, though not both, but they all achieve my top requirement of vibrant color.

WATERCOLOR TUBES

You've probably seen little cakes of watercolor in pans, but you can also find tiny tubes of watercolor alongside them in stores. Watercolor tube paints are often squirted into small pans or paint wells where they live until they're all used up. These are the most versatile of watercolor paints as they are colorful alternatives to buying paints in cakes, which are already placed in pans.

As opposed to cake watercolors, these are less chalky and dry and therefore can hold more color. My favorite brand of tube watercolors is Mijello Mission Gold. They offer a wide range of professional watercolors in an array of colors. They can be used heavily for a dark, full color or watered down to pale hues. These paints are archival, meaning that your painting is guaranteed to look like it did on its first day for at least a lifetime. My large palette is often in my art table photos. Sometimes, just looking at it is inspiring!

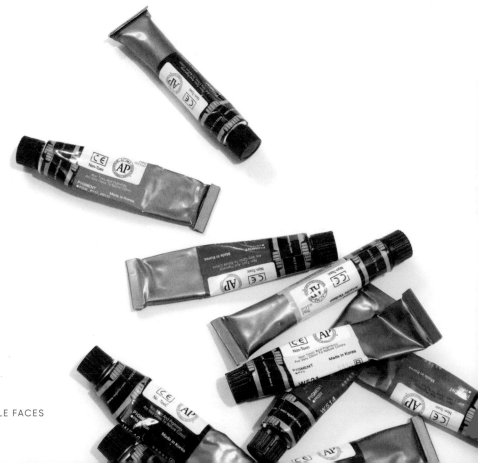

FLUID WATERCOLORS

Fluid watercolors are a little less known as they're not often found on the shelves alongside watercolors. The small bottles can resemble inks. My favorite feature of using these liquid watercolors is what I call the "whoosh"-effect. If you've seen videos where color is dropped onto a wet sheet of watercolor paper and the color seeps through like a moving flood, you can understand why I call it that. These paints not only spread fluidly, but the color breaks down into nuances of cotton candy hues. The paints' greatest downfall is that its glorious color fades over time and with exposure to sunlight. Since I work as an illustrator, scanning my work and capturing it for commercial reproductions, it's a downside that I can cope with. But these paints may not suit you if you like to hang your work to stand the test of time.

WATERCOLOR PAINT PAPERS

A handy batch of hand-picked skin tones introduced in a later chapter, these watercolor sheets are great to have at your reach or to take on-the-go! Simply wet the papers with a brush to activate the paints. The colors are rich, and once dry, they can be stowed away in a sketchbook. I recommend the Expressive Little Faces pack by Peerless Paints.

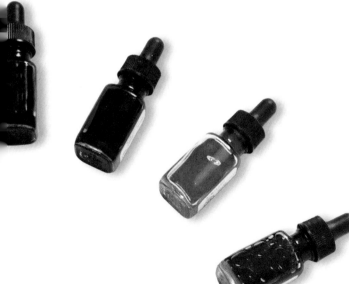

INKS

BLACK INDIA INK

India ink is inexpensive and highly accessible. It's dark and great for creating a range of grays from dark to light. It lasts longer than most other types of ink because you don't need to use as much at a time. I've used several brands and have found that which I reach for all depends on its usage. For this book, though, I use an inexpensive brand because I don't need it to be as permanent or rich in texture as I would for calligraphy. But be careful: No matter how watered down, it can still stain your clothes.

WHITE INK

A fluid white that can be used independently or as an additive to watercolor not only gives you light tints on your existing colors, but creates a different quality of colors. You have to mix them to see it! Though not required, a fluid white helps expand your color experience. I recommend Dr. Ph. Martin's brand.

COLORED INKS

Colored inks are a fun alternative to just black. They don't come in as many colors as watercolor paints but one could find a set with every basic color quite easily. I especially enjoy using iridescent inks to give my work a touch of shimmer. Use a brush that you don't need, since inks can be difficult to wash out once dry. Also, the colors work as additives and therefore don't break down as fluidly as with black India ink; you may find it difficult to create a variety of shades from one color.

INDIA INK TIPS

India ink is inexpensive, but a little goes a long way. A large bottle as shown below may last a lifetime. When purchasing ink, look for India ink that dries permanently.

Since it does dry permanently, it can be a headache to wash out of a palette. I like to repurpose water bottle caps as ink basins that I can toss after use. While this is a great option for an all-black drawing, when you explore creating and using gradients—shades in varying degrees of intensity—you may need several bottle caps or to use a traditional palette that you reserve for use with India ink (see page 97 for an example).

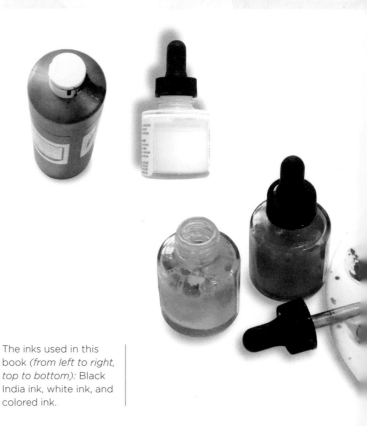

The inks used in this book *(from left to right, top to bottom):* Black India ink, white ink, and colored ink.

BRUSHES

Artists can get particular about their brushes. After all, they serve as extensions of our hands, objects that must not wander too far out of sync with our brains. Despite the heavy responsibility we place on them, I'm not given to expensive brushes, but I do have some prerequisites when shopping for a paintbrush.

The first factor I look for is whether the hairs are neatly together. A harried or furled-looking brush yields those same types of strokes. The hairs of the brush could be natural or synthetic, but I don't typically purchase brushes whose hair length is long. The more the hairs can move or bend, the more likely they are to wander into areas I'd rather they not. The most important feature I look for is the tip. Particularly with round brushes, I want the tip to be pointed like a well-sharpened pencil. This type of brush serves me well with small details, and the width of the brush indicates how large those brushstrokes can get. A full-bodied brush with a fine tip makes marks ranging in size from its finest end to its broadest girth.

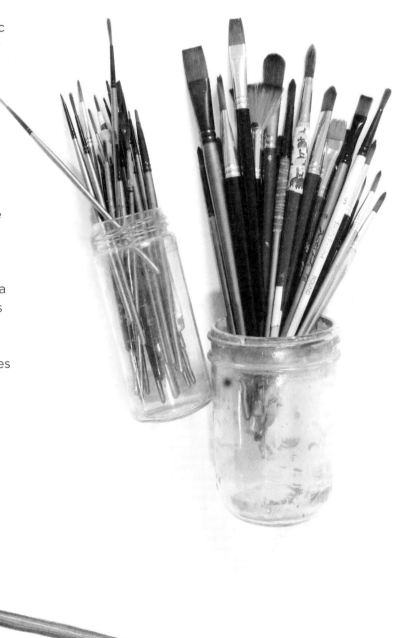

FLAT BRUSHES

Flat brushes look like square brushes; their bristles or hairs are chopped in a flat line at the top. These brushes are usually used to cover a lot of ground on the page while offering clean corners. I like to use them as an interesting element of shape and texture; a flat brush loaded with paint and water offers a structured twist to the usually-fluid watercolor shapes, and a dry flat brush offers a linear texture that can be used for shading or for texture in hair.

ROUND BRUSHES

More often than not, though, I'll reach for my round brushes: one larger brush for laying in the washes of paint that create the foundation of our faces and a smaller brush to work within those shapes, bringing your face to life. Depending on the size of your face, you can be flexible with brush sizes. I tend to reach for my size 12 or 8 brush the most for larger applications and my size 4 or 2 brushes for smaller features. If you tend to work looser and approach creating with a carefree spirit, use a larger brush in your hand in order to work at a larger scale. Those who may label themselves perfectionists may prefer smaller brushes, even down to a size 0 for painting every last eyelash. I like the Master's Touch brand of brushes.

WATER BRUSH

A handy game-changer, the water brush is great for on-the-go painting, eliminating the need for a messy cup of water. The water is contained within the body of the brush handle, and you only need a quick squeeze to release water when needed. I prefer the Arteza and Pentel brands.

MARKERS

Dry mediums, including markers, are great for on-the-go applications and small details. They offer more control, though little-to-no line variation in their marks. It took me some time to come around to liking markers for this very reason. Little did I know that there were markers that addressed this desire for line quality while remaining versatile.

BRUSH MARKERS

The brush marker, or art brush, has been a surprising nonnegotiable travel buddy in my art bag. Convenient for its marker-like properties and cultivator of creativity with its brush-like characteristics, this hybrid art tool delivers ink through synthetic bristles. These plastic bristles are loaded with ink with each squeeze of the body of the marker. You may find, however, that a dry brush marker is just as fun as one seeping with ink, as the drybrush technique offers a raspy texture that's both interesting and realistic in certain treatments. I recommend the Pentel Art Brush Pen.

FINE TIP MARKERS

Find these in the office and stationery aisle just about anywhere or seek out a professional set at an art supply retailer. I enjoy prepping a page with watercolor blotches and having it ready in my sketchbook to take along with a fine tip marker. Uni-ball pens and Pigma Micron Markers both work great for this.

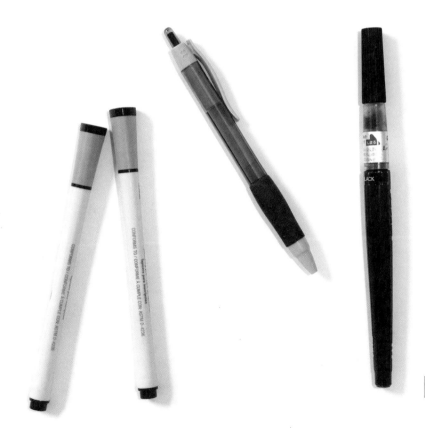

Brush markers and fine tip markers.

WHITE GEL PENS

I often feel quite satisfied with a finished painting of a little face, but I also remind myself that adding little touches of white makes such a difference. The quickest way to these extra twinkles of white is with a gel pen. They're inexpensive and within easy reach. I especially like the Uni-ball Signo White Gel Pen.

PAPERS

The most common mistake I've seen students make is using an incorrect paper, particularly when painting. I like a bright white paper that may be a touch thicker than necessary. That said, the first paper choice is not always high-end quality!

SKETCH PAPER

I don't think that artist's sketch paper has much of an advantage over good quality copy paper. Copy paper is easier to access, which means it doesn't hold the "precious" quality" that artist's papers do, so it's optimal to get any mental hurdles or inhibitions out of the way when you're ready to sketch.

WATERCOLOR PAPER

Through teaching students at various skill levels, I have seen several use cardstock paper or similar thick papers in hopes of bypassing the need for watercolor paper. I get it. And yet, these papers are simply not comparable. Watercolor paper is made of cotton or cotton-like fibers tightly compressed together to hold heavy amounts of water, allowing the paint to set on top. The paper holds while the lush vibrancy of the color shines. Thick papers that are not manufactured this way may hold light brush strokes, yet the color will appear dull and be unable to blend with other colors as it sinks through. Let me put it this way: If these papers could talk, cardstock paper would take one look at what's on your brush and call it colored water. The watercolor paper, however, is happy to play with the paint, understanding the water is the slippery slide that allows movement on the page!

With all that said, my desire is to make painting as accessible as possible. I wholeheartedly recommend a couple of inexpensive watercolor paper choices to you. These can be found quite easily and are affordable. You'll find these two on my desk on any given day: Canson Watercolor Papers XL Series and the Strathmore Watercolor Visual Journal spiral for on-the-go painting. Look for paper that is cold-pressed as it will have fewer bumps for beginners and always go for at least 140 lb (170 gsm) paper weight.

Art supplies are great and beautiful to have about us, but they do little on their own. While they offer eye candy and rouse an exciting gurgle in our creative hearts, they're only as powerful as the hands that hold them. The items I've discussed in this chapter are not an exhaustive list, but if you find it exhausting, don't worry; all you really need to get going is an old-fashioned pencil.

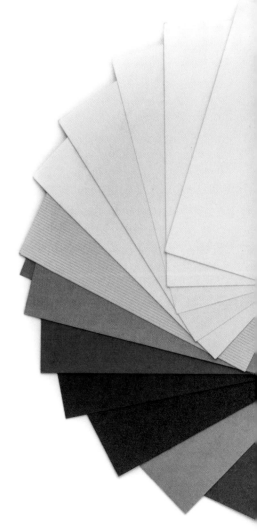

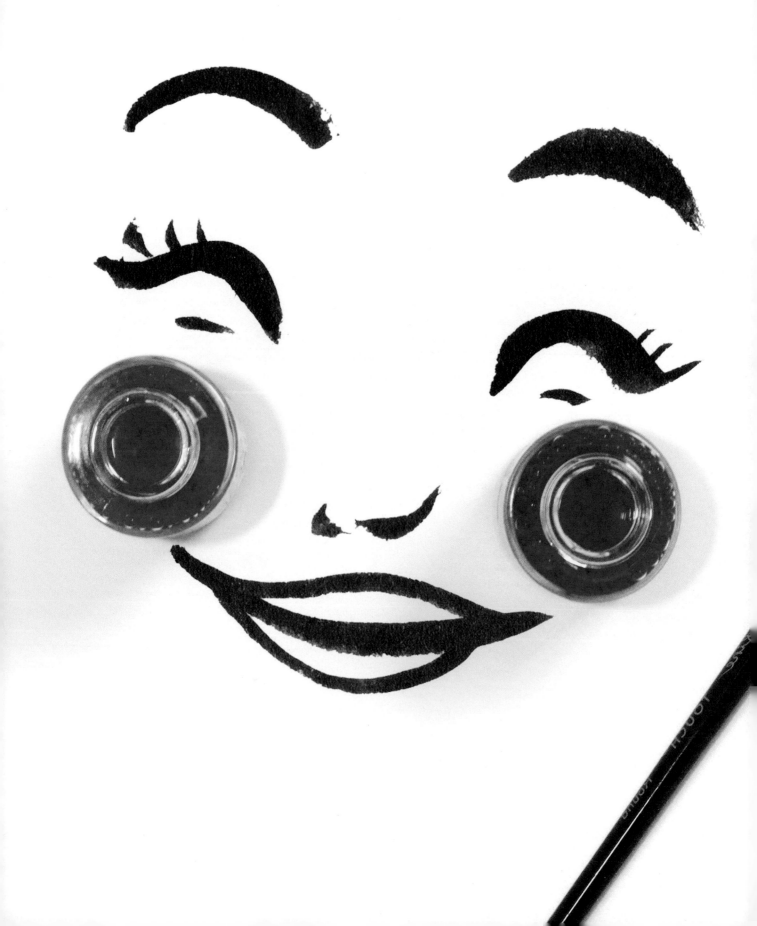

2

SIMPLIFYING THE FACE

You've heard it before: SIMPLIFY! Easier said than done, right? It's true—simplicity can be quite tricky, particularly when we're instantly taken by a person's overall appearance. But perhaps you'll feel better framing the challenge this way: We will become experts in *focusing on what's essential*. The greatest of artists did this as part of their creative journey of discovery (deconstructing parts and reducing them to shapes) or as a consuming illustrative style. In this chapter, we'll home in on the important features of a face as well as the unforgettable ones. Faces are not as complex as they appear; we need only to shed what's inessential and simultaneously shed intimidation.

SHEDDING INTIMIDATION

GRADATIONS OF SIMPLICITY

Faces have been portrayed in so many different ways. We can bring it down to the simplest of common depictions, such as a smiley face, or the most complicated, rendering each pore. What satisfies most tastes and allows for a wide range of personal stylization is aiming for something in the middle—a face that is not only distinguished as a face but also as one that belongs to a certain person, be it imagined or found in real life. The faces in this book may vary in degrees of realism, but they land somewhere in the middle of where all the facial features are described and where there's still some allowance for expression. I want to leave creative space for you to be inspired to apply whatever stylistic adjustments you prefer.

GETTING UN-SCARED

Faces are complicated, or at least we perceive them that way: all those features, varying in sizes, proportions, distances from each other, small details—the list goes on. What might be most intimidating about faces is that we can read them all at once. We see expression, feeling, ethnicity, perhaps even cues to personality all in one glance. Drawing a face is like looking at an entire galaxy and having to not only depict its millions of stars on paper but also portray its overwhelming impact on your heart. It may seem like an impossible feat. But painting faces is a process. You are not responsible for representing every layer of the person you see in a single glance and a single brushstroke—or even in every brushstroke!

I remember drawing and painting family members early on. I wanted to pour all I felt about them into my painting. I wanted them to feel honored, seen, and most of all to not be offended at how pronounced I made their nose. But instead of gushing warm feelings into a piece, it oozed with all the angst that I carried throughout the process.

One word will carry you through, chant it: simplify. Focus on what's most important in the face you're depicting and then settle on details later. Despite the fact that we can quickly digest visuals, what we remember are the most pronounced features. Glasses are memorable, as are thin lips or very full lips, skin tone, hairstyles . . . it could be almost anything! It only depends on the face.

Simplifying the face is twofold:

1 Where are the darkest darks?

2 What can I not afford to glaze over?

THE DARKEST DARKS

The darkest darks are commonly in the same areas of the face. Home in on these areas of contrast and you'll be addressing what's most important. Dark areas typically are:

- The corners of a smile where the teeth recede into darkness

- Eyes, be they light-colored or dark

- Nostrils or shadows below the nose

- Shadows around the eye

- Hair, depending on shade

I'll spend most of my time showing you the bare bones of a recognizable face, and we'll build from there. Soon, you'll begin to look at faces and see these most notable features, but for now, let's do a quick shortcut: Let's play with our phones.

CAN'T-MISS FEATURES

Before we assume that faces are simply a collection of shades, we can't miss the can't-miss features of each face. Who would Aunt Elizabeth look like without her deep dimples or Uncle Benji without his square glasses? I'll tell you who they wouldn't look like: Aunt Elizabeth or Uncle Benji. We each have a feature that people most remember about our faces. They may not be able to describe our face for an accurate police sketch, but they'll remember that mole, the unique shape of our eyes, or our hairstyle. Using my picture as an example (see image on page 31), most people remember curly hair and glasses. They may forget the slight gaps in my teeth or my overgrown baby nose, but I'm sure that the eyewear and curls would be enough to place me in a lineup!

Learn to pick up on a person's key details. They may be tied to an ethnicity if you, the viewer, has had less exposure to those features, or they may simply be more pronounced aspects of the face. Whatever they may be, these details are truly can't-miss features that are nothing but foremost in carrying across the face of your choice in your art.

Use these two principles to simplify the face to its most important bare bones whether you're painting a face in front of you or one from your imagination. You will be able to come up with more unmistakable details as you become more comfortable describing the points of highest contrast. As we take the face apart and address each feature, I show you how to paint the minimum, but the sky is the limit. Be free to elaborate once first things are placed first.

PHONE HACK

Photographs are likely the first step in shedding intimidation when painting faces, and we can use them to simplify the face simply by adjusting their contrast. This gives you a clear understanding of what to focus on when you set out to create a recognizable face.

1. A quick and simple way to find the darkest darks on any face is by first snapping a picture.

2. Once captured, hit Edit. Change your photo to be a black and white image. You can also select the saturation option and lower it all the way, or your phone may have a setting or filter to turn your photo to grayscale instantly.

3. If it's a dark picture, you may have to brighten it first or vice versa.

4. Adjust the contrast on your image. Slide the contrast range ridiculously high until most if not all of the shadows are gone.

Let's pick on me. Here's an image of my face in full color, then desaturated to shades of grey. Now, here's my face with very high contrast, which is almost a straight black and white image. The darkest darks in my face are my eyes, my hair, the corners of my smile, and a faint shadow under my nose. The shape of my face and chin are easily outlined by the darks of my hair and the shadows cast on my neck. These are the areas I want to be sure to hit. I can paint myself in splashes, shades of the rainbow, arbitrary marks in lighter hues—the pressure is largely off to portray likeness, and I can be free to reimagine my face! But, we're not done listing the priority areas.

IDENTIFYING PROPORTIONS

Facial proportions can be counterintuitive. This section gives you an easy-to-follow guide that neatly divides the face into quadrants. I walk you through which features correspond to different sections and how to place a person's eyes, nose, and mouth to get a symmetrical, beautiful face.

PROPORTIONS MAKE THE FACE

Faces can be puzzling. But maybe seeing them as a puzzle would actually serve us better. The varying proportions of our facial features are what defines one face from another. In this chapter, we are going to break the face down into parts and thereby create a map for placing each part of the face proportionately. I use the word proportions a lot, but please don't be intimidated by that jargon. This is how Lexico.com defines proportion:

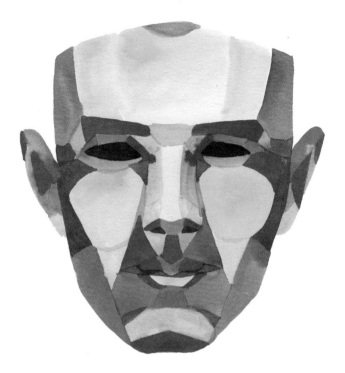

> **Proportion,** *noun*
> —A part, share, or number considered in comparative relation to a whole.
> —The relationship of one thing to another in terms of quantity, size, or number; ratio.
> —The comparative measurements or size of different parts of a whole.
> —Dimensions; size.
> —The correct, attractive, or ideal relationship between one thing and another or between the parts of a whole.

In short, let's just say proportions are how big or little something is in relation to something else. The truth is that we all have different portions in our face. Some of us have rather large noses in comparison to our eyes, while a baby's eyes usually dwarf its nose. There are bounds to these proportions, however, and they provide the edges of the area we get to play in.

PRACTICE: FACIAL PROPORTIONS

Let's jump right into an activity that clarifies many of your questions regarding how to construct the face. We'll draw a face with lines that work as guides—a roadmap—for placing facial features.

1 An oval face is a great place to start. Make an elongated circle and then add a bit of definition at the corners of the jawline and add a hint of a chin.

2 Draw two lines from the edges of the chin upward. If it helps, draw a line down the middle and then broaden from there. This will look like a tunnel, and it is: This is the tunnel of the nose.

3 Divide the head into thirds horizontally. Then, draw a horizontal line right across the middle. You now have three large sections with the middle one divided into halves.

 This will all pan out on the next page as we begin to add in the facial features and make sense of these sections.

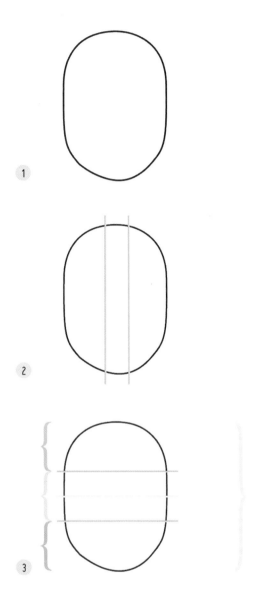

Note that I've hidden the lines from the step above just for clarity; you may keep yours.

4 Your face should look like a collection of lines that are similar to a face guard.

These are the horizontal sections you've created:

- The upper portion is the forehead and part of the hair. The hairline will fall within this portion.

- The middle section will hold most of the main facial features, from the eyebrows to the bottom of the nose.

- The bottom portion includes the mouth and chin.

5 Let's begin to draw in the features. Don't worry about how they look; we're simply learning where to place them.

Start at the top with the eyebrows. The top line of this middle section marks where to place the eyebrows. Beginning from the inside out, their starting point is along the sides of the nose. They end well within the bounds of the face, a width similar to that between the sides of the nose and the edges of the face.

6 The eyes are right in the middle of the head! Because our hairline muddles our clear view of this, we often place the eyes too high on the face. Like eyebrows, the eyes also begin around where the sides of the nose extend. If you're wondering how wide to make the eyes, sketch lightly or imagine a row of five eyes. This may look bizarre, but they serve as helpful guides for where to place the eyes and how wide to make them. Draw them as two simple almond shapes along the center line.

7 Working our way down the face, let's draw in the nose. There's a section that focuses on how to draw the nose, but you can draw a hint of it as best you can for now. You can draw a U-shape, a set of nostrils, or just its outer edges.

8 The mouth is all that's left on the face, landing right in the center of the bottom section. You may find it easiest to first draw the middle line of the mouth, or the opening, and then extend upward and downward for the top and bottom lips.

9 The face is in, but it's not complete without a pair of ears. We can use the same lines from our face layout to understand where the ears go. If you feel your own face, tracking a line with your finger from the outer corner of your eye to your ears, you'll notice that's where your ears begin. Trace a line with your finger back again from the bottom of your ears to your face and you'll land at the bottom of your mouth. Draw your ears based on these observations.

10 Feel free to place more details from here to make your face feel finished. I added a bit of hair and eyes, as well as some lines.

You may like to refer back to this guide on facial proportions when you need a refresher on how to construct a face.

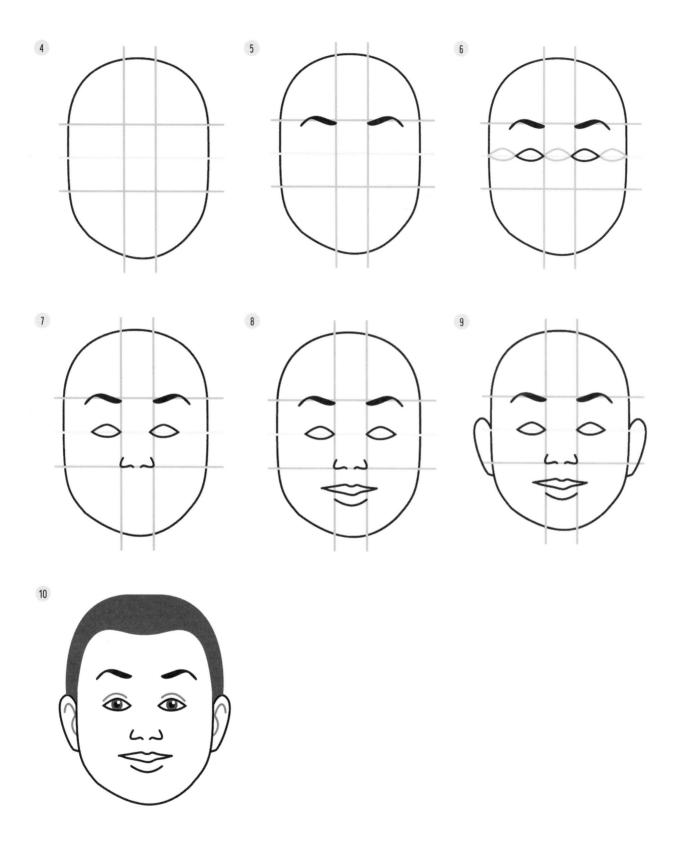

HEAD MOVEMENTS

Now that you understand proportion a little better, the temptation may be to create this generic face all the time. But as you perfect this proportionate face, you'll start to notice slight alterations to this ideal when looking at other people. This exercise of understanding the bounds in which we create facial features is also inadvertently teaching you to notice its downfalls. Comparing and contrasting are powerful learning tools—they are tests to the conventions you've been taught thus far.

You may have already wondered: What about faces at angles? We don't always get the privilege of seeing and drawing faces head-on. They're often tilted or looking off slightly in one direction. Though this isn't an exhaustive view on how to draw faces at angles, this helps you approach the challenge with confidence.

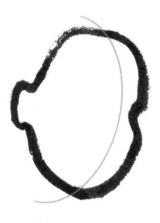

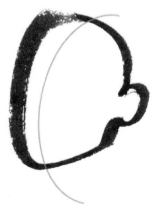

PROPORTIONS AT ANGLES

Having a face in your hand that can be turned and tilted may prove to be a handy tool. Let's replicate the face we see on our fruit, taking a careful look at our fruit faces to learn some points.

- Our face shape becomes narrower as we turn the fruit left or right.

- Facial features are at slight angles. Notice how the eyes which we drew in equal proportions become smaller on the side that is angled away from the viewer.

Now, we add more to the limited information our fruit can offer us.

- A facial feature that needs an obvious change is the nose. The nose protrudes—but not off our fruit. Place a small line of shadow along the vertical side of the nose.

- The narrow face shape also needs some dimension. Extend the lines outward just a bit at the forehead. Add a small bump for the cheeks.

- Draw a line along the side of the extended cheekbone to the chin.

PRACTICE: FRUITY FACE

1 Grab a mango or any other oval-shaped fruit.

2 Give the mango a face with simple, balanced features using a permanent marker.

3 Turn your fruit face from side to side, looking at the face from different angles. Notice how the eye farthest from yours looks smaller or even darker. Notice the angle of the eyebrows: once level, now angled away.

4 Try to draw what you see.

5 Despite not having all the planes and protrusions that faces have, this is a great exercise for noticing how features appear to foreshorten and lengthen when angled.

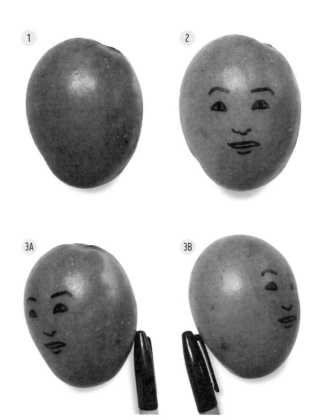

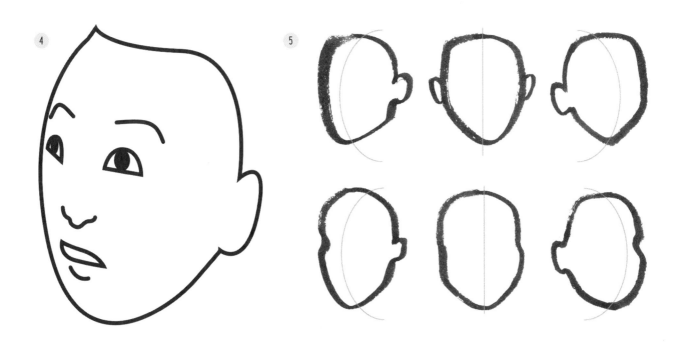

SYMMETRY IS IMPORTANT (BUT SYMMETRY IS A MYTH)

The simplest way to make your subject look proportionate is with symmetry. Academic studies show that symmetry is the first thing we notice in someone's face, and a face's lack of it is deemed the most detrimental to assessing its beauty. And yet, symmetry itself is a myth. Not one of us is perfectly symmetrical, and it makes sense: We are organic creatures, not a collection of rigid pixels arranged into shapes. So, how do we handle this tension of symmetry's tantamount importance along with its false expectation?

We use the visual tool of balance to ease the eye. While symmetry is a calculative equality, something we can measure with precision, balance can hold the same impact while allowing room for interpretation. It's incredible how quickly our eyes can call out "something isn't right here," when there's a lack of balance. But other factors at play that make an equally aesthetically pleasing sight could prevent some of us from noticing an uncentered couch or a slanted wall hanging. For example, the couch that is not centered with the fireplace may have different elements on either side of it, perhaps a large plant counterbalancing a side table. The wall hanging that is askew may appear even along the bottom, or perhaps the ceiling above it is sloped as well. This is how we can approach the features of the face. No two eyes are identical, but they will be looking in the same general direction. The eyebrows above them may not angle at the exact same points, but they look similar enough for the viewer not to notice them. Focus on the balance of dark lines or their relative shapes as you mirror the many paired facial features and try your best to make them equidistant from each other.

It's important to not fret about symmetry for more reasons than our own sanity, since a slight lack of symmetry can be quite endearing. A crooked smile stands out to our eyes and can make us feel unsure, untrusting, but a slightly crooked smile feels much more genuine than one that could be advertising toothpaste. Why? These little nuances of change remind us that we're relating to a real person. We are aware, deep down, that symmetry is unhuman. Looking at a face that is not altogether perfect makes us feel much more at ease in our own skin and think, "You're like me! Imperfect and lovely." A small mole on one side of the face does not go unnoticed, but it's thought to be charming. A dimple may not be part of a set, and eyeglasses worn slightly askew are more common than not.

Consider these factors when creating. You're not just drawing a face, you're representing a human. This person who lives on your paper (or perhaps one that's alive somewhere) must bear his or her slight and delightful imperfections at the first impression. Consider it a lovely trait of us humans to be able to accept and quickly embrace others' imperfections, providing us with a wonderful amount of license to create without fear.

KEY TAKEAWAYS

Can you believe that you know how to use proper facial proportions, angle those faces as they move, and single out what matters most? We've learned a lot in just two chapters!

Practice a few more simple, idealized faces. Though you may feel the temptation to create this generic face all the time, try to notice how the people around you have slight alterations in their proportions. This exercise of understanding the bounds in which we create facial features is also teaching you to notice it downfalls. No measurement or diagram can teach you how to draw a face as well as taking the time to observe one in real life.

We now shift gears into looking at each facial feature. We have such a wide variety of styles to choose from with each feature. Once we explore these, you will have a mental roster of several parts of the face, like menu options with which you can construct a variety of faces.

Asymmetrical: A natural approach to painting the face.

Symmetrical: Both halves of the face are mirrored, which looks too perfect.

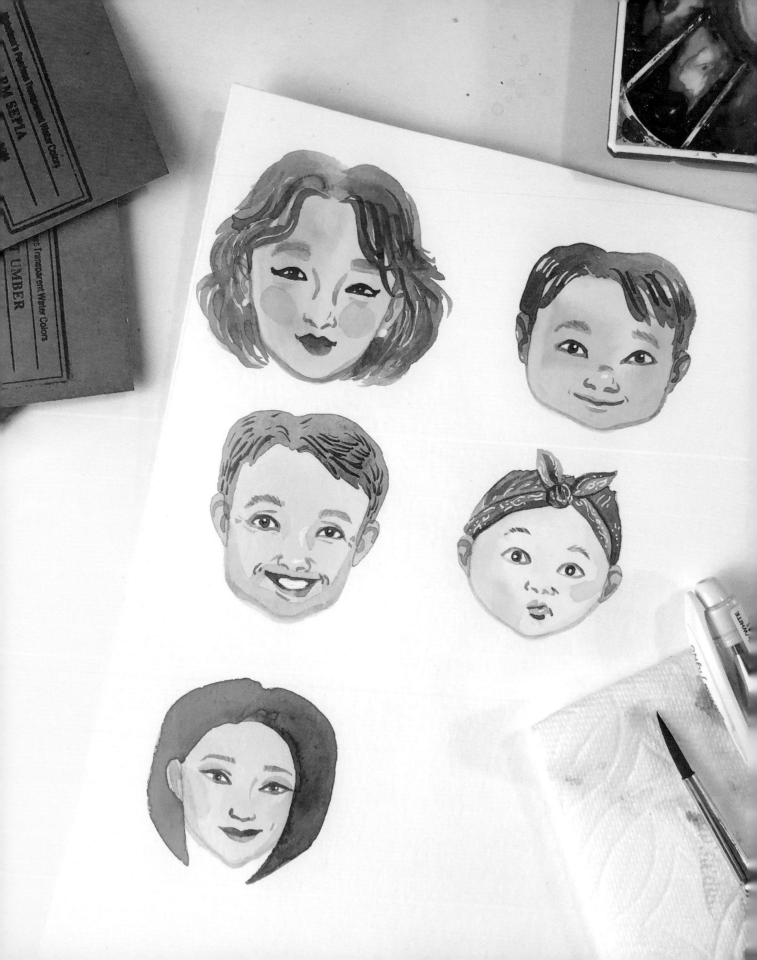

3

BUILDING
A FACE

We know what is important and we know where to put it—it's time to put these faces together! In this chapter, we discover the face feature by feature and explore the options for and questions about each as we construct them into a single face. Beginning again with what's most essential, we look at a handful of face shape options, then confront the most fun and expressive feature: the eyes! From there, we work downward, taking a quick stop at the nose and then playing with mouths. Finally, as we transition deeper into personality, we tackle hair. Each feature plays an important role in developing the appearance of our person and propels us closer to meeting them face to face.

FACE SHAPES

Before recognizing their features, we notice a person's face shape. This makes face shape one of the most important elements of creating a face.

Here, we explore the five face shapes and the changes you can make to chin lines, ears, and hairlines to enhance a face's form.

BASIC SHAPES

Round. Round face shapes are fairly common, particularly since so many Asian populations have them. These faces tend to look calm or joyful, as the cheeks take up more space. Children often have round faces before shedding their adorable baby fat.

Oval. This face shape is thought to be the gold standard of beauty for its sense of balance. However, you'll find plenty of supermodels with other face shapes!

Rectangular. Check out that strong jawline! Those with this face shape naturally appear strong. (Think *The Terminator*.) But this face shape isn't only for males—although it's a great shortcut to a male face if you struggle with that—females can also look quite elegant with it.

Square. This is the same strong jaw as rectangular, but with a shorter face. The square face shape is as long as it is wide, just like a round face, but replaces its curves with an angular jaw. From forehead to jawline (and cheekbones in between), a consistent width is prominent throughout. These faces could easily lean European and feel very approachable.

Heart-Shaped/Triangular. Perhaps the most exotic of the face shapes, the heart shape or inverted triangle is the widest at the forehead, tapering down in width to a subdued jawline that emphasizes the cheekbones.

PRACTICE: PIZZA FACE

Make a face with each of these five shapes and use pizza ingredients as facial features. How about a mushroom nose or pepperoni cheeks? Could cheese make a fun hairdo or do you prefer bacon tendrils or pineapple waves?!

Just like pizza needs a bed of dough, your face is going to need a shape. We then "stack" our facial feature toppings on it. As discussed, faces come in five general shapes, and only one of those is a round pizza shape . . . although I've eaten every shape on this list!

Hungry yet?

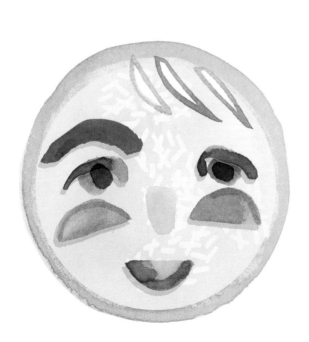

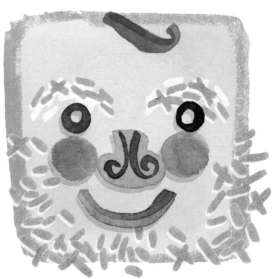

ENHANCING SHAPES: ADDING CHIN AND EARS

Try your hand at painting some face shapes, adjusting the outline of the chin and adding ears to help ground them.

1 **Shape the jaw and chin.** As you paint each shape, taper it at the base to give form to the jaw and chin. Chins can be square, rounded, or pointy—just like faces!

2 **Place the ears.** As discussed on page 34, the ears are placed so they surround the midpoint of the eyes. The ears begin at the eyeline, then rise up before dipping down to the mouthline.

3 **Emphasize the jawline.** Outline the jawline to paint the face shape.

4 **Add details to the ears.** Besides their solid basic shape, ears only need two or three lines. Place one line parallel to the ear's top edge to define the shadow of the crease there. Add another line to give a hint of the shadow of the *tragus*, the tiny curve that hangs over the opening of the ear. You can play with the placement of these lines and add another shadow along the ear's bottom rim. These lines can be curved or not, pronounced or subtle.

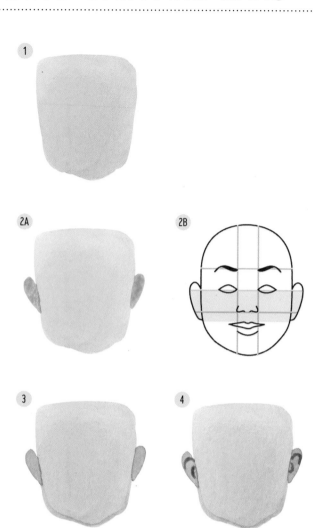

BUILDING A FACE
STEPS 1 AND 2 OF 6: FACE/CHIN SHAPE + EARS

These five faces may look bare, but we'll add features as we travel through this book's process, developing them in 6 steps.

In this section, we learned that the shape of the face is critical. Making subtle shifts in the lines along the jawline can make for an eye-pleasing face, while knowing the variations of shapes has already opened the door to lots of different faces!

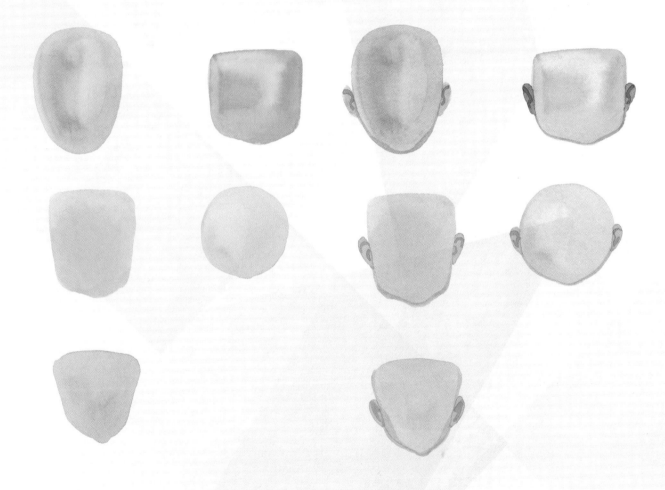

CREATING EYES

Creating lifelike eyes is essential to creating an expressive little face. In this section, I show how the shape of an eye changes, depending on where it's looking (and from the perspective you're looking at it). We also discuss eyebrows, eyelids, and eyelashes and how each play an important role in developing and altering the eye's appearance.

Eyes Can Be Easy. The approach I take to drawing and painting eyes is often the simplest! These two elements—a curved line for the eyelid and a dot for the whole of the iris—are all you need to convey a variety of expressions. The eyelid's curve can go up or down, raise or flatten, while the iris roams within. You may have noticed that some of your favorite artists simply use dots or dashes for eyes—and I'm not just talking about cartoonists and illustrators! Consider Amedeo Modigliani (1884–1920), who used flat colored shapes for the eyes in his oil portraits. This method will easily do the trick, taking the guesswork out of drawing eyes, but keep in mind that the fewer the elements, the more limited you'll be in portraying expression.

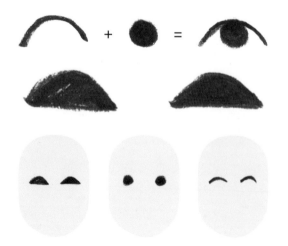

CARTOON EYES

Cartoonists must be able to capture facial expressions because their characters often jump from one extreme emotion to the next. Do any of these common approaches to drawing cartoon eyes inspire you or include any details that you'd like to incorporate into your style?

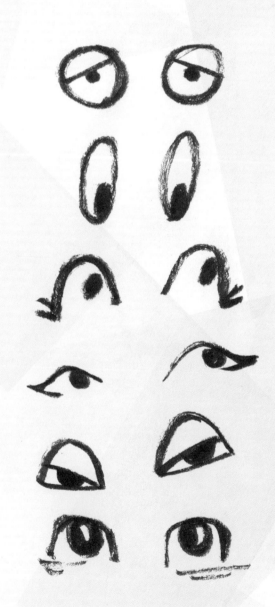

EYES IN 1, 2, 3, OR 4 STEPS

Let's ease into drawing eyes with this exercise.

1 Step. Simply draw small hills or crescents [A]. These eyes typically look happy—unless you make them squint in anger!

2 Steps. All you need is a curve and a solid iris [B].

3 Steps. Simply adding a line beneath the 2-step eye gives it a more substantial look and offers more potential for expression [C]. A variation on the 3-step eye plays with length and curvature in the eyelid line and varies the line weights in the top and bottom lids [D].

4 Steps. Move the bottom eyelid to the edge to add a hint of wrinkle and create depth with a simple fold line above the eye [E].

Step Up from Simple. Ready to add a little more detail? Small additions like eyelashes can make a world of difference [F & G].

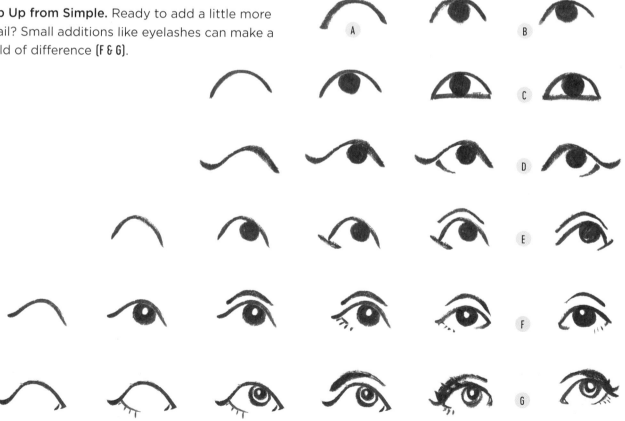

DRAWING EYES IN PENCIL

On the previous pages, I used marker to show the simplest approaches to drawing eyes. Graphite pencil, by contrast, is a much subtler medium. The range of darks and lights you can get from a pencil means more choices and making judgments in pressure and intensity. More choices mean greater complexity—both in creating the subject matter and in the viewer's ability to interpret it. While the steps are basically the same, I've added details to help you navigate the level of pressure you'll need to apply to your pencil to get the desired effect.

1 The eyelid is always a great place to start. It provides a "roof" for the eye and determines its shape.

2 All the marks made in this step are light. In adding the lower lid, be careful not to extend its line beyond the halfway point from the outer corner—a fully outlined eye doesn't look natural. Also, add a tear duct in the inner corner, a lightly drawn shaded nook near the center of the face. All it takes is one small line to create the barrier between eyeball and its fleshy attachment. Another important part of this step that isn't shown in the marker version is the shadow the upper eyelid casts on the eyeball. This lovely detail gives depth as well as a hint of the eye's inherent curvature. This shadow falls on both the white of the eye and the iris.

3 Add the fold of the upper eyelid, making the edges a little darker. This midway point of our drawing process is also when we move on to medium-darks. You may want to go over the upper eyelid again if you'd like it to be darker. Also draw the pupil, taking care to leave a bit of white for glare or twinkle.

4 The eyes come together with the introduction of the iris. Color them in lightly for light-colored eyes and apply more pressure for darker ones. Don't stop filling the iris where it meets the upper shadow; instead, layer your shading so the iris and the shadow overlap and intensify each other.

5 To finish, add a hint of shadow where there's a bit of puff under the eyes. Adding emphasis to the lower lid will give your eyes a "down-to-earth" look, a sense that the person is more like me. Keep it subtle if you'd like to avoid giving the eyes a tired or aged look. Darken any areas that should be at their darkest—the pupil, the corners, or parts of the upper lid. If you like, add eyelashes, which lend a touch of realism. Apply as shown for a natural look—these eyes could be male or female, as the lower lashes are small and subtle—or add thick eyelashes to the upper lid for a bombshell feminine look.

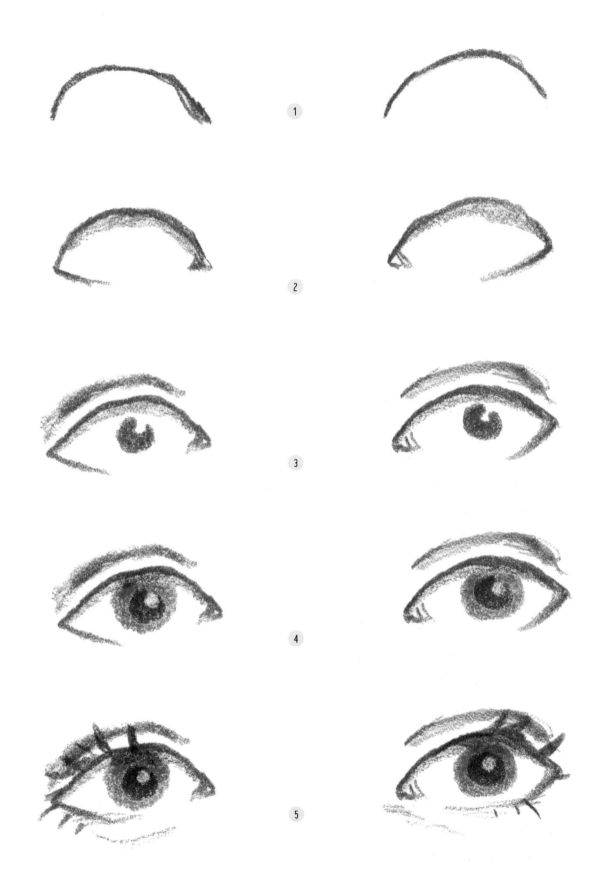

EXPRESSIVE EYES

The time has come to put together all that you've learned! Try your hand at drawing different expressions with these tips.

Surprise. The eyes and eyebrows come up to reveal the entire iris of the eye. Accentuate the alarm as a cat would—with raised hairs or, in this case, eyelashes [A].

Skepticism. We often cast our gaze upward to show skepticism. Even if the person we're facing is lower than us, we cock our head sideways to make this expression work. Therefore, the eyes gaze upward while the eyebrows do the opposite of each other—one raises while the other lowers [B].

Eagerness. The hopeful eyes look up and show little whites as the face is smiling or pleasant. A few hints of squinting wrinkles add a lot of expression [C].

Anger. The eyebrows obviously play a big role in a traditional expression of anger. The muscles under the eyes push them smaller, halfway squinting, as if the brain is also dealing with the shock of trying to understand how this can be. You may also want to add a line between the eyebrows to show rage [D].

Worry. Again, we see the effect of the eyebrows as they slant up and slope downward. The eyes can be looking in any direction and as wide as you'd like, but these classic eyebrows do all the talking [E].

THE EYEBROWS HAVE IT

The expression, that is! Tightly structured or curved, arched or angled, hairy or sparse, eyebrows are fantastic for expressing emotion. These lines above the eyes are tools of surprise, envy, wonder, anger, and skepticism. Don't obsess over making eyebrows (or eyes) perfectly symmetrical: They're sisters, not twins.

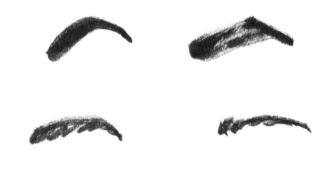

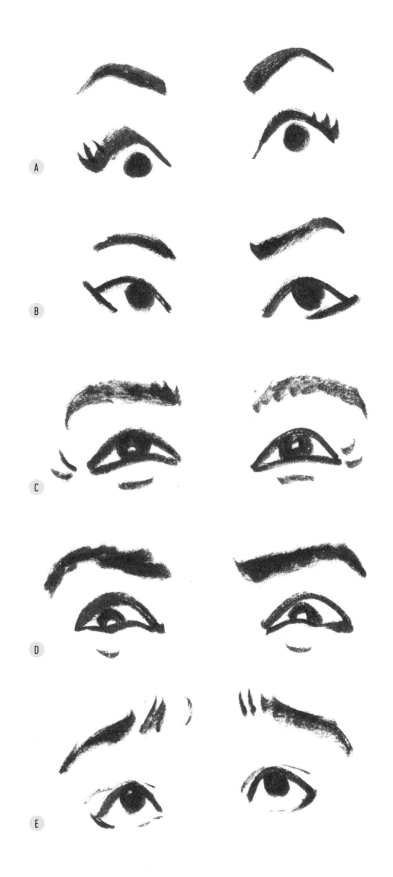

PAINTING EYES
IN WATERCOLOR

While there are myriad values from light to dark that can be achieved with watercolor, two values of one watercolor paint are all you need to portray eyes with a touch of depth. Remember to always work from light to dark, allowing each layer to dry before applying the next.

1 Begin with a light watercolor by working with a brush that's loaded with more water than paint. Create the outline of your eye.

2 Lightly paint the entire iris, taking care to leave a little area of white to serve as a light glare.

3 Load your brush with more paint than water for a second, darker layer. Outline the upper eyelid.

4 You may choose to fill the iris completely or only partially if the eye color is light.

5 If desired, outline the bottom lid with the darker shade.

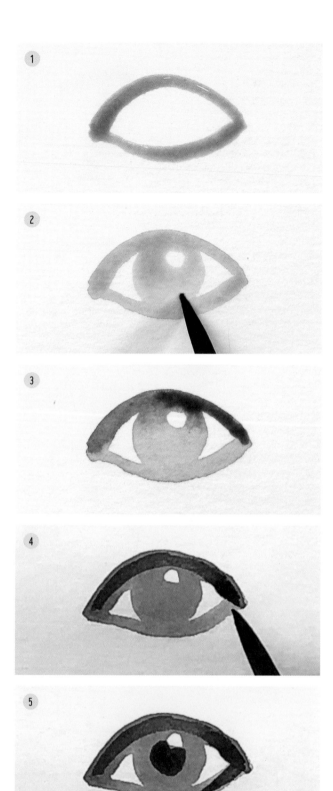

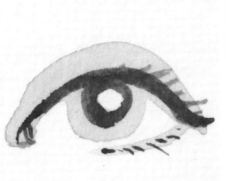

This eye is also painted using just two values, but the darker one is applied with the very tip of the brush to create fine lines that allow for more small details. Also, the line of the eyelid is thinner, giving more space for eyelashes, while the lower lid is only touched on a second time to suggest small lower lashes.

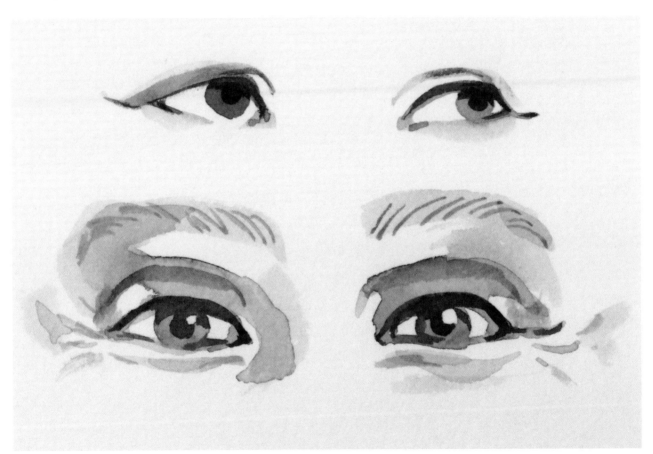

Treat eyes with care and they'll speak volumes to your viewer. Paint a few eyes and then give yourself the challenge of creating sets. Practice painting eyes looking straight ahead before trying different angles, with the eyes roaming in unison in various directions.

PAINTING A SET OF EYES

FEMALE EYES

You'll be eager to make them a complete pair after practicing one! In this demonstration, I created the first eye before working on the second one, but it's great to work on both at the same time, which allows time for each to dry before the next step.

1 Repeat steps 1–3 as shown on the previous spread (page 52). Add in the second step of darks. This time, be careful to place the pupil in about the same place as its mate.

2 Paint the pupil and then add a corresponding shadow over the eye in a crescent shape. It adds to the roundness and depth of the eye.

3 With a light load of paint on your brush, create swooping lines for eyebrows, painting outward from the center of the face.

4 Allow to dry and then add hints of brow hairs in a slightly darker shade. These eyes feel so much more grounded and natural as a pair and with eyebrows providing a visual anchor.

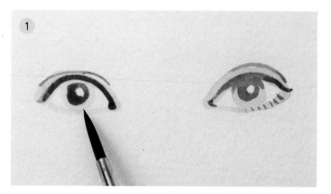

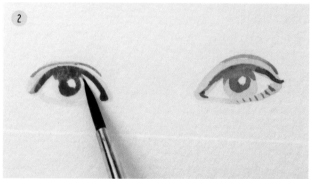

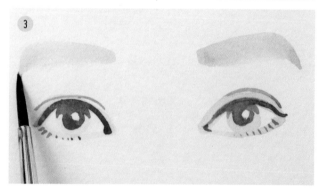

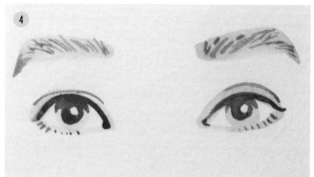

MALE EYES

Male features can be tricky, as less is better with men—less color on the lips, fewer eyelashes on the eyes, fewer dark lines. All of these are to retain a natural look but can leave us defenseless to "fixing" mistakes by adding more paint. The best approach to men is to capitalize on the darkest features while adding a few rugged lines.

As you might expect, color also plays a role in giving a minimal or rugged look to a male face. I used light washes in blue and brown to create the general form as well as the lightest shadows. As an additional step, I added the shadows inside the corners of the eye sockets and under the eye. They show how the parts surrounding the eye are higher, leaving the eyes in a valley.

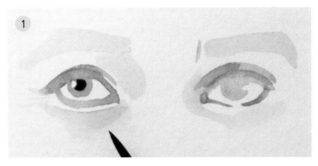

1 The pupil always gives the eyes that magic touch of direction. You can achieve this effect with the darkest value. As it is, this right eye has all it needs for definition.

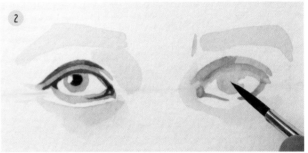

2 Place darkest shadows on the corners of the eye and the crease of the eyelid. Use the tip of your brush to assure a controlled line that doesn't get too thick or look like eyeliner.

3 Wild brow hairs and a few proud wrinkles finish the look of these dreamy eyes, wandering off. Notice how they are not perfectly symmetrical and yet work well as a set.

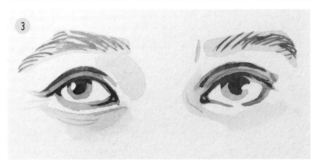

GLARE IN THE EYE

The touch of light in eyes is critical to adding a lifelike feel to your faces, but you may not always choose to place it on the pupil. In addition to being a reflection of light near the eyes, it's also a way to convey emotion. Notice how glossy the eye on the right looks by placing the glare on the lower edge of the eye. It gives the feeling of watery eyes rather than twinkling ones.

Wherever you choose to place that flicker of light, be consistent with both eyes. You may choose to give your eyes both a watery look and a twinkle.

TAKEAWAYS: EYES

We've learned that both simplified eyes and those requiring a few more strokes and subtle washes can make us instantly relate to the faces we see.

A face full of joy just needs squinted eyes and a few smile wrinkles. The styles vary, but the human emotion, its spark of personality, is what must shine. This happens when we put the emphasis on the key places of interest in a face.

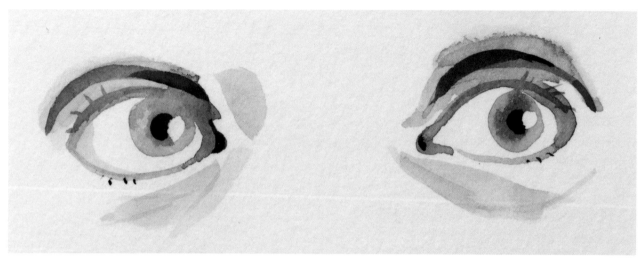

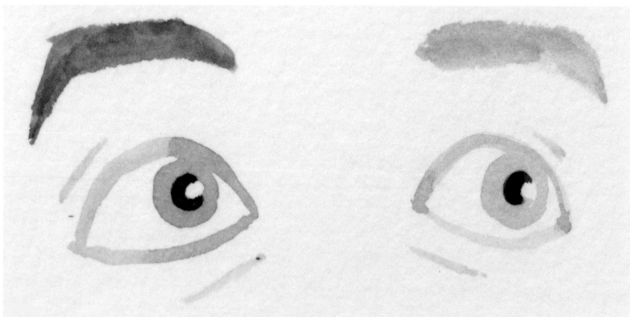

As long as the eyes are kept wide apart, an expression of surprise only needs a few lines.

BUILDING A FACE
STEP 3 OF 6: EYES

Our five faces take immediate shape with the addition of eyes. I first outline a variety of eye shapes, their corresponding eyebrows, and smile lines with a darker flesh tone. These thin lines work like a pencil sketch, laying out where each part goes. I can then freely add eye color and definition as shown in the next step.

You'll see our face shapes again in the section on noses, page 66.

Eyes are paramount to the expression and tone of our faces. They also give us hints to ethnicity as much as they do to enthusiasm. Starting out light with a flesh tone–like color is a great way to build up layers as confidence grows. Don't forget to consider the lines surrounding the eyes—the eyelids, the smile lines, or a subtle addition around the eyes. Eyes can be portrayed very simply and yet still carry the weight of a face's identity quite well.

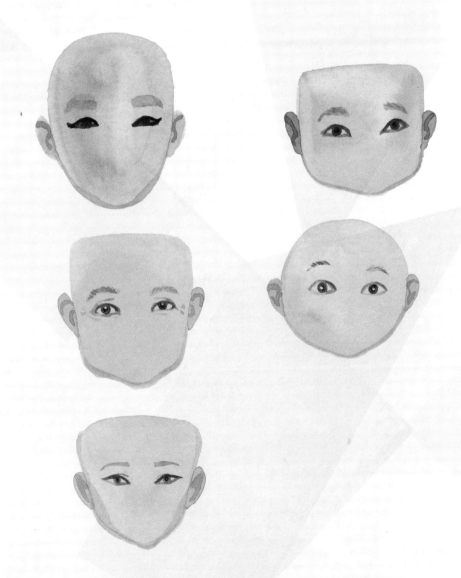

CREATING NOSES

Because noses are a collection of shadows, they're often thought to be the most difficult facial feature to portray. In this section, we make a variety of noses with just a few simple strokes and discuss secrets for avoiding overpronounced noses and other common nosedives.

NUANCED NOSES

If you would say that your nose is your least favorite of your facial features, you're in good company. The majority of people across nation-alities are quite nitpick-y about their noses! They're either too big, too pointy, too round, too wide—you get the gist. Personally, I always felt mine was too flat, but when I was living in Asia, they regarded it as tall. Why? We were looking at different parts. Asians tend to prefer a tall bridge,

while in the West, we only seem to worry about the tip of the nose.

As many of us know, the nose is made up of cartilage, and therefore in terms of drawing, the nose is a collection of shadows. There are no harsh lines and other than nostrils (if visible), no stark darks either. And since the methods described in this book focus on the darkest darks, I have good news for you: The less you do to interpret the nose, the better! This means that I want you to get in and get out of there pronto. An added bonus of the less-is-more approach is that the other features will rise to the top in importance, and if you're drawing a loved one, they may be relieved to not see their least-favorite feature . . . well, featured!

AS MINIMAL AS IT GETS

Your goal is to do very little to depict the nose. Let's begin as we always do with the darkest darks. Two obvious darks arise when looking at the nose. The nostrils are the only dark shape at the end of the smattering of shadows that lightly guide the eye down the nose's tunnel. The second darkest darks are the sides of the bottom of the nose. If I were to really go for the simplest nose, it'd be what I've come to call "the parenthesis and the two dots." This may appear to be a very crude way to draw a nose, and it is, but it is a powerfully simple starting point. The shape of those shadows as well as the shape of the nostrils require a touch of attention and nuance as we compare one face with another.

If the nostrils aren't visible, the shadows along the sides of the nose may connect along the bottom to create bracket-like shapes. Having a button nose myself, I sometimes lean toward this type of depiction.

DRAWING NOSES

As with every facial feature, we're going to see a variety of nose shapes, shadows, and variants. Let's look at the different directions we could take in imagining our person (or drawing from real life). We start with the four strokes we've already introduced, the nostrils and the boundaries on either side of them.

Are the nostrils round or angled? Sometimes, nostrils are round or oval. These are both shapes that appear as though they are flat on the face. Sometimes, nostrils are angled upward, in which case the opening is more visible from the sides than from the front **[A]**.

What about the shadow? Since the nose protrudes from the face, it oftentimes casts a shadow below. Depending on its size and the lighting, that shadow could appear as a dark shade cast underneath or two shadows that may or may not meet in the middle **[B]**.

When light hits a face head-on, that shadow below may disappear entirely. Instead, you may notice a darker cast of the shadows on either side of the nose. You may hardly see much shadow at all or choose to not place much emphasis on it if a nose is so small that it doesn't protrude much, like that of a baby **[C]**.

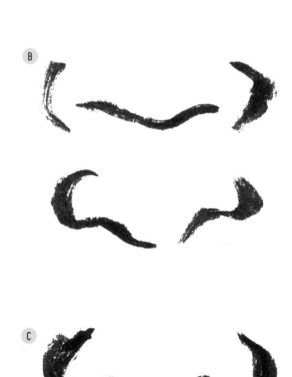

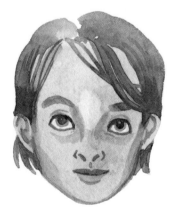

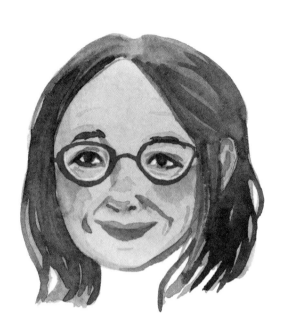

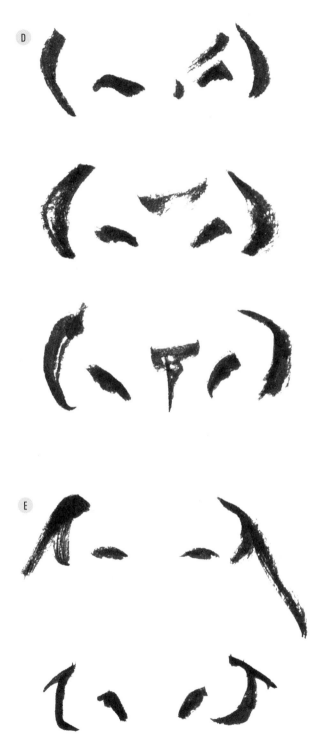

A nose might need more than one shadow. Perhaps the bulb of the nose protrudes, but not enough to cast considerably. Perhaps the nose is more structured than round, requiring a few more lines. Do be careful to simply address these added areas of shade without dwelling on them too much (D).

Smile lines (see also "A Variety of Smiles," page 72) are very important. These tiny strokes that indicate what the cheeks are doing are great for adding a slight indication of emotion and age. Most of us naturally have a hint of shadow or line there, where our facial muscles collide with each other (E).

It's those little considerations that make a face feel real and relatable—no matter how imagined.

DRAWING NOSES IN PENCIL

I showed you the different ways to address a nose in stark black and white so that you could see exactly what was being pointed out as its darkest darks. Pencils work best when practicing noses with a wide range of values since noses are a collection of nuanced shadows. I prefer to sketch lines rather than blur or smudge them. This allows me to practice applying varying weights of pressure with my hand in order to get the right shade of gray. Those who are new to drawing tend to draw with a heavy hand. Sketching noses—though they make for an odd collection of drawings in your sketchbook— is a great way to break free of the tendency to draw heavily.

 Practice some noses in graphite and re-render the ink portrayals in the spread before. Play with different sizes, features described, and placement of shadows.

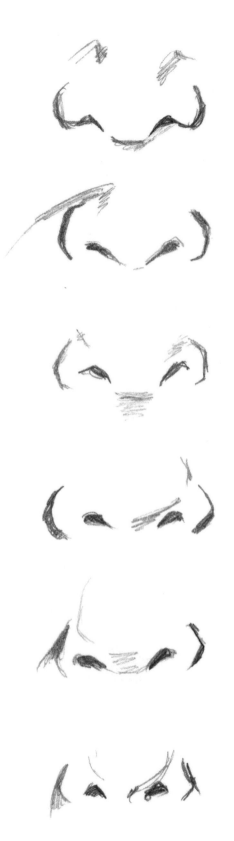

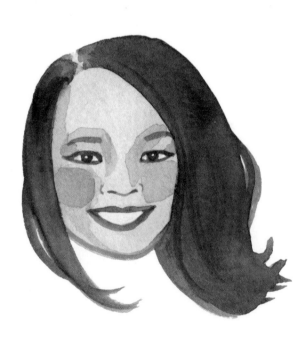

NOSES FROM VARIOUS ANGLES

Noses may be the facial feature most affected by the turning of the face. A subtle shift in the tip's shadow can curve the shadow that hangs below the nostrils, requiring more shading on the side of the nose that is away from the viewer.

Before we begin to worry too much about where the shading goes, we may do well to imagine a pyramid. As the pyramid turns away from us, the other two planes (on the far side and beneath) adjust and shorten.

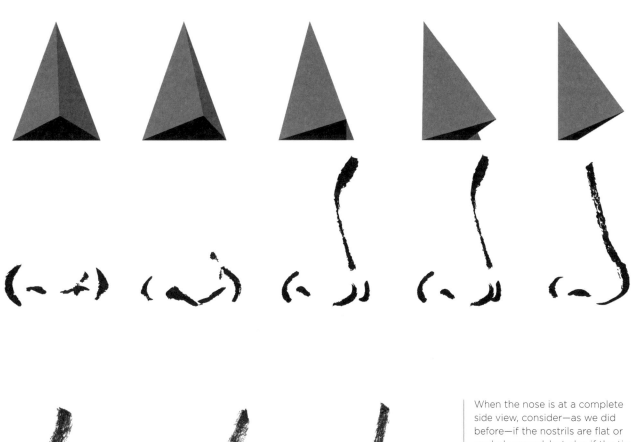

When the nose is at a complete side view, consider—as we did before—if the nostrils are flat or angled upward, but also if the tip of the nose is pointy, rounded, or angled up or down.

PAINTING NOSES IN WATERCOLOR

Moving on to watercolor painting will be a welcome, smooth ride away from smudging pencils and harsh marker lines. The light washes of watercolor are a natural treatment for portraying noses. Remember that most people would say that this is their least favorite facial feature. Therefore, it's wise to do only what's needed, the nostrils and a few hints for shape. As in real life, noses are best left barely touched and lightly handled! And as always with watercolor, we work from light to dark, large areas to small. I used some contrasting colors in these examples so as to make the layers of painting easily distinguishable for you. Feel free to use a darker skin tone for this painting portion.

1 The "two dots and the parenthesis" approach takes on a nuanced shape with watercolor. The dots are half-almond shaped and angled slightly toward each other.

2 Use a light wash to create the side edges of the nose.

3 If needed, create light shadows with three brushstrokes: one broad one below and two on either side extending toward what might become smile lines.

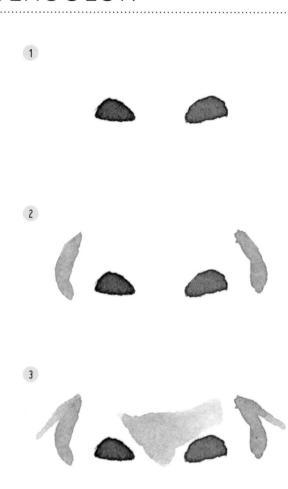

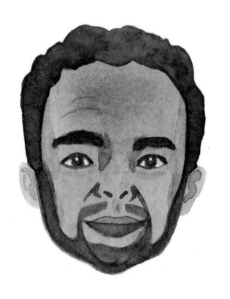

A light tone lays down the framework and shadows. Notice how they're essentially a channel up from the bottom of the nose but break just above where the nose protrudes off the face. You may notice shadows above or below the nostrils.

The single thing to fear when painting noses is overdoing it. Simpler is better. Breeze through painting the nose, and you're well on your way to creating the entire face.

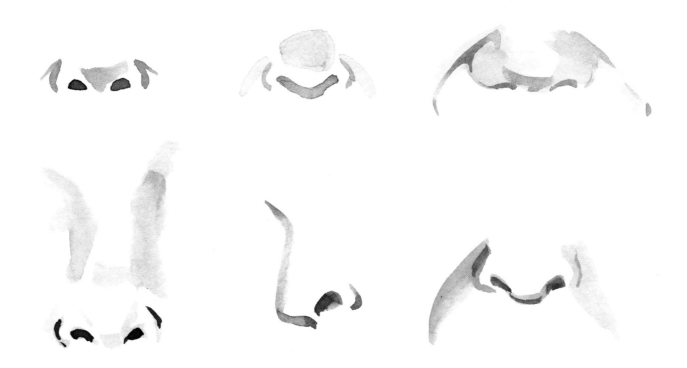

BUILDING A FACE

We return to our familiar faces with noses. Try to practice some of the nose shapes shown in this chapter . . . you have five faces to try them on. Place the nose roughly halfway between the eyes and the chin, depending on how pronounced the chin is. We return to our faces at the end of the next section on page 81.

Noses don't receive a lot of praise, but they do get a lot of attention when something is not quite right. Keep it simple by omitting the numerous shadows that make up the nose because less than a handful truly matter.

We move down to mouths next, completing the facial features. The mouth carries a lot of expression, and it's a place where we can have even more fun!

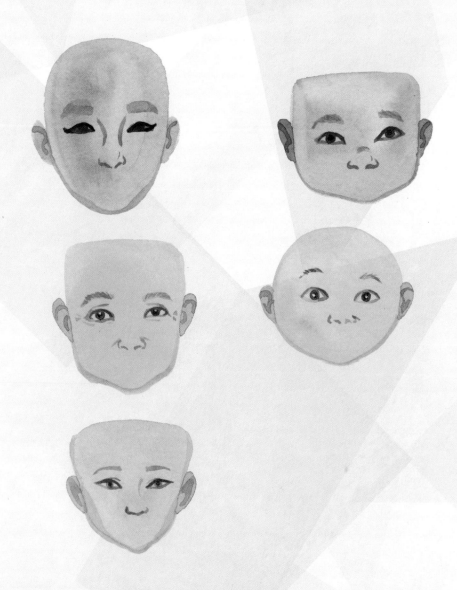

CREATING MOUTHS

In this section, we learn about the variety of mouth shapes and the traits that differentiate them. We also see that "a hint of teeth" is better than a fully realized set and learn how to add lines to suggest facial movement.

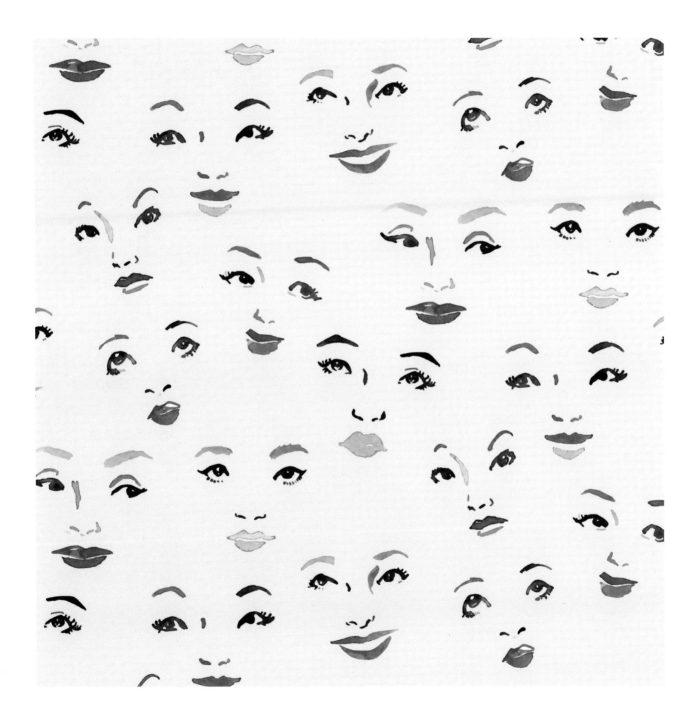

SIMPLE LIPS IN THREE STEPS

Mouths are relatively simple, and their placement on the face is clearly marked. However, they can range from large to small, with lips that can be plump or thin, wide or narrow, marked by a great dip or not . . . there are so many options! As usual, before we start to see all the possibilities, let's distill the mouth to a very simple approach.

If you're ready to take your mouth game up a notch from a smiley face, you only need one or two more lines: A wavy line at the top to describe the arches of the upper lip, a middle line that can lay flat or express emotion, and a bottom line that curves to form the bottom lip. This method may feel freeing or oversimplified, but either way, it works!

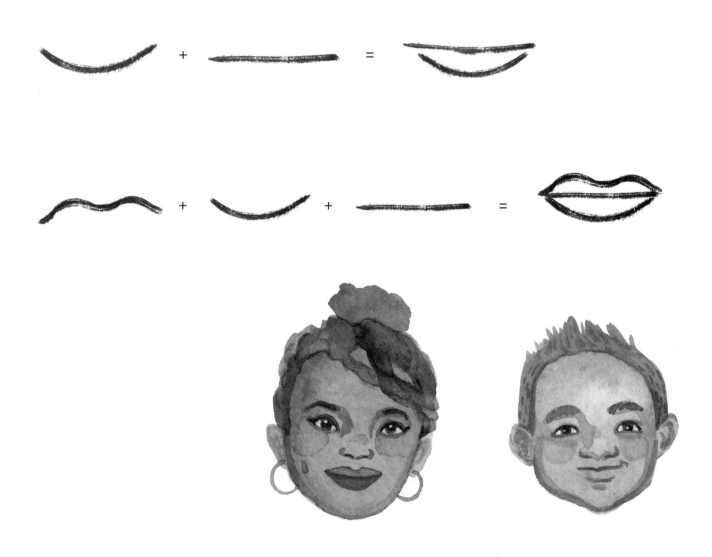

MALE MOUTHS

Don't hesitate when tending to this facial feature. Guys have mouths! Simply use a less-is-more technique. Here are some tips to keep you from overdoing it.

Choose to draw either the lower or upper lip. Don't outline the mouth fully. Of the two, the lower lip is a more typical choice, but if a man has full lips that are prominent, just drawing the upper lip with a hint of the bottom can look great.

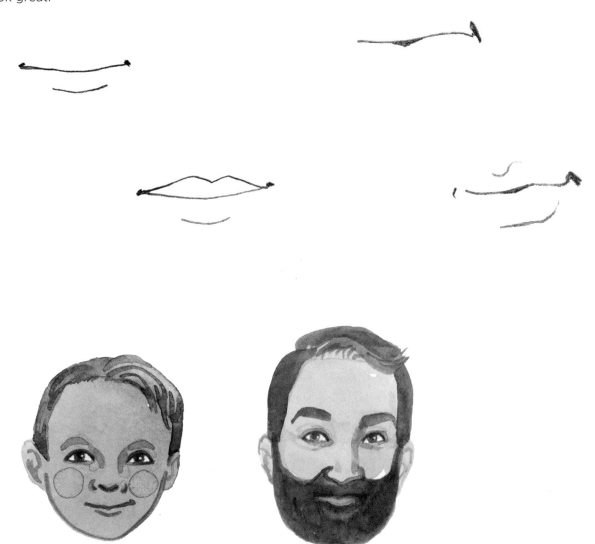

Focus your attention on the middle line, or the opening of the mouth. It is, after all, where the darkest darks may be if the mouth is slightly open. A touch of shadow in the center or at its corners allows for a natural take on an expressive mouth. Allow the viewer to connect the dots as they imagine the missing lines.

A touch of facial hair can be a fun addition. This can also leave you free to be a bit more heavy-handed with your drawing, outlining the mouth or increasing the darks as the viewer already has a clear sense that the subject is a man.

Coloring (or lack thereof) also offers a cue toward masculinity. We tend to reach for pinks and reds for mouths, but men's bare lips are more nuanced versions of pink or are barely colored at all. A simple approach is to use a slightly darker or rosier version of the man's skin tone.

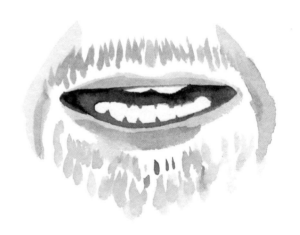

OPENING THE MOUTH

You may be surprised to notice that not all mouths open in the dead center. Notice the corners of someone's mouth when they smile. Also note that, unless you're drawing a dot-eating, yellow-faced circle, the lines that make the openings of the mouth are not flat.

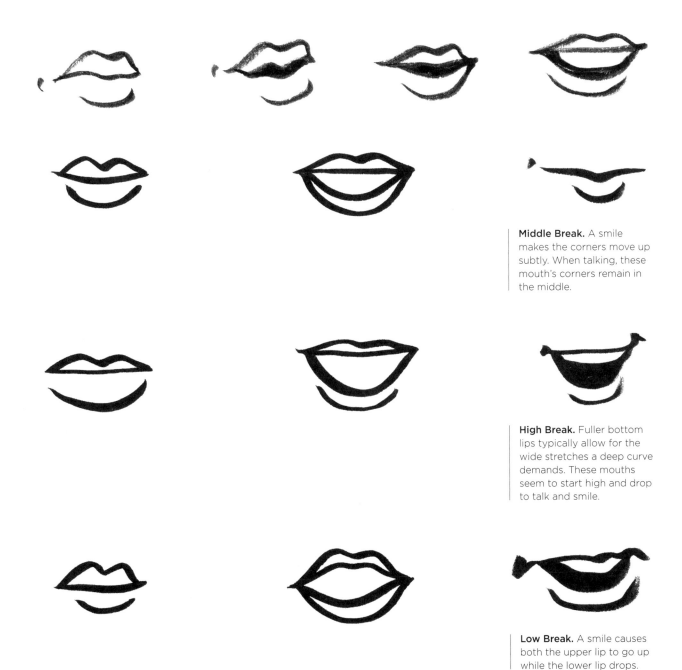

Middle Break. A smile makes the corners move up subtly. When talking, these mouth's corners remain in the middle.

High Break. Fuller bottom lips typically allow for the wide stretches a deep curve demands. These mouths seem to start high and drop to talk and smile.

Low Break. A smile causes both the upper lip to go up while the lower lip drops.

A VARIETY OF SMILES

We're going to ask a lot of questions now! You don't need to address all of these, but they'll help you notice the differences between mouths— what makes each one look the way it does.

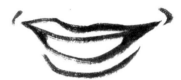

Smiles. Not all smiles are the same. I may show my teeth for pictures, but my kids know that a grin or a smirk is just as warm.

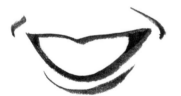

Placing Darks. We learned that the corners of the mouth tend to be dark areas we don't want to ignore. But how much dark? Just the corners or a little extra on the bottom, perhaps with a hint of bottom teeth showing?

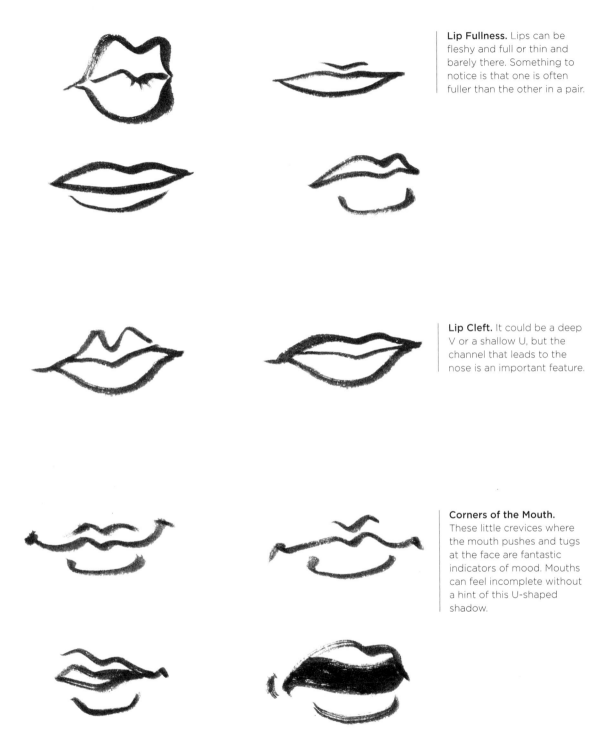

Lip Fullness. Lips can be fleshy and full or thin and barely there. Something to notice is that one is often fuller than the other in a pair.

Lip Cleft. It could be a deep V or a shallow U, but the channel that leads to the nose is an important feature.

Corners of the Mouth. These little crevices where the mouth pushes and tugs at the face are fantastic indicators of mood. Mouths can feel incomplete without a hint of this U-shaped shadow.

Teeth Showing. Do the teeth show when they're talking? If so, top row of teeth or bottom row or both? I remember as a little girl noticing my grandmother showed her bottom row of teeth when talking or smiling.

Mouth Opening—Wide or Narrow? Does their mouth open all the way to the corners, or does it open just a bit in the front?

EXPRESSIVE MOUTHS

You may have already dabbled with a few but push yourself to explore more varieties of facial expressions. Some quick photos can help you explore different expressions. A little observation goes a long way. Here are a few hints for your expressive mouths:

- **Smile lines aren't just for smiles.** Those lines on either side of the mouth offer just as much expression to a sad frown, a horrified grimace, or a disappointed pout.

- **Remember to focus on your darkest darks, and in this case, they land right in the center of the mouth.** Don't be afraid to fill in darkly. The stark contrast demands the viewer to pay attention to what emotion is being portrayed.

- **Expressive faces are best explored in batches rather than one at a time.** You can learn so much from comparing and contrasting. If you find yourself stuck at just a few ideas, pushing through that mental block might open the door to more creative drawings.

- **Note how upper or lower teeth are exposed depending on the emotion.** The corners of our mouth turn upward for a gentle smile and a large laugh. They turn down at the slightest argument or embarrassment.

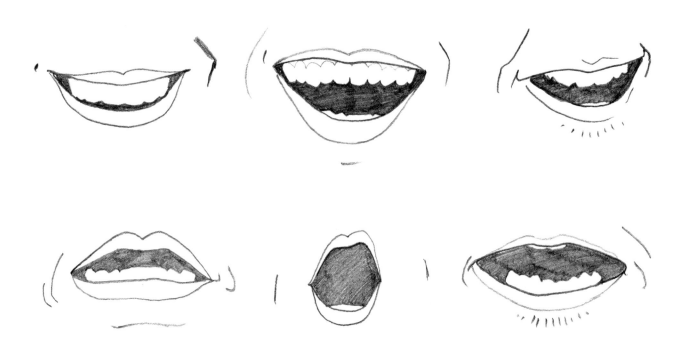

PAINTING MOUTHS IN WATERCOLOR

Painting a watercolor mouth can be as simple as three plus three: three large watercolor strokes, made with the body of the brush, plus three thinner strokes to clean up edges or tighten the mouth's appearance.

1 A great advantage of holding a brush over holding a utensil of dry media (like a marker or pencil) is the flexibility to create differing line widths. Begin your upper lip with the point of your brush and then gradually press to create a full hill shape. Don't hold it down for long, as you'll need to relieve the pressure again as you finish your first stroke at the center of the upper lip.

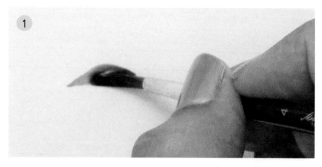

2 Repeat this process—light tip, full body, light tip—to create the second half of the upper lip. This process may not come naturally at first, but it is well worth the practice.

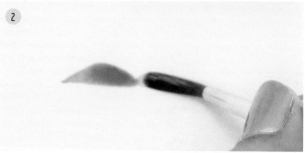

3 Feel free to use the tip of your brush to smooth any edge that may appear rough. No one is going to judge your painting by how many brushstrokes you used, so do what you feel is needed to create the shape of the upper lip.

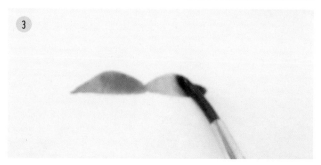

4 I like to paint the bottom lip in a slightly different color. This is a personal choice; when I teach, doing this also allows my students to see the brushstrokes much more clearly.

5 Similar to the upper lip, use varied pressure to create the form, but this time, you only need one hill shape from corner to corner. Begin with the tip of your brush, press to use its full width of hairs, and then let up again at the end. Smooth as needed.

6 We now add thinner, darker lines with the tip of the brush. A single line does the trick to give a touch of shade. Add two lines on either side much like parenthesis to give our pout a grin.

7 Three large strokes + three thin lines = one pout!

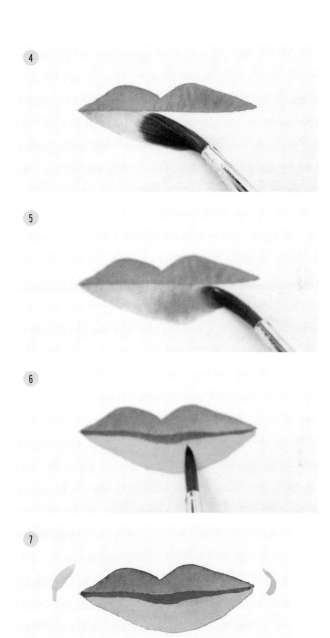

PAINTING AN OPEN SMILE

An open smile may feel like an open invitation to "mess up" your face painting thus far! Believe me, it's not. Who doesn't love a good smile? As with painting the nose, you'll find that a few tactful touches will go a long way. Here are three key things to keep in mind:

- As the lips will be stretched, consider making them thinner with a shallow (or no) dip in the upper lip's cleft.

- Shadows make the shape. The medium-value color used on the lower part of each lip as well as the dark corners within the mouth have the power to create an instant pop.

- A hint of the gumline may be all you need to describe teeth. If you'd like to add more definition, do so from the top of the gumline down or from the bottom of the teeth upward. Never outline each tooth.

1 As we did before, begin your smile with varied pressure to create two hills and a valley. This time, however, stretch the shape to create a smiling upper lip. Smooth the bottom edge.

2 With a wet brush, create the bottom lip by beginning the brushstroke with the tip of the brush, pressing to extend the hairs, and letting up again at the end.

3 Create a hint of shadow by adding more paint to the brush and lining the bottom sides of both lips. Soften with a moist brush if the lines appear too harsh.

4 Add a hint of teeth as well as a hint of color to create small points extending from each corner of the teeth. Err on the side of less rather than more.

5 With a brown or another dark color, bring in the dark corners of the smiling mouth where the shadows fall most. Use only the tip of your brush for this precise shape.

6 Finally, add some light smile marks on the cheeks to frame your beautiful smile and make it more personable.

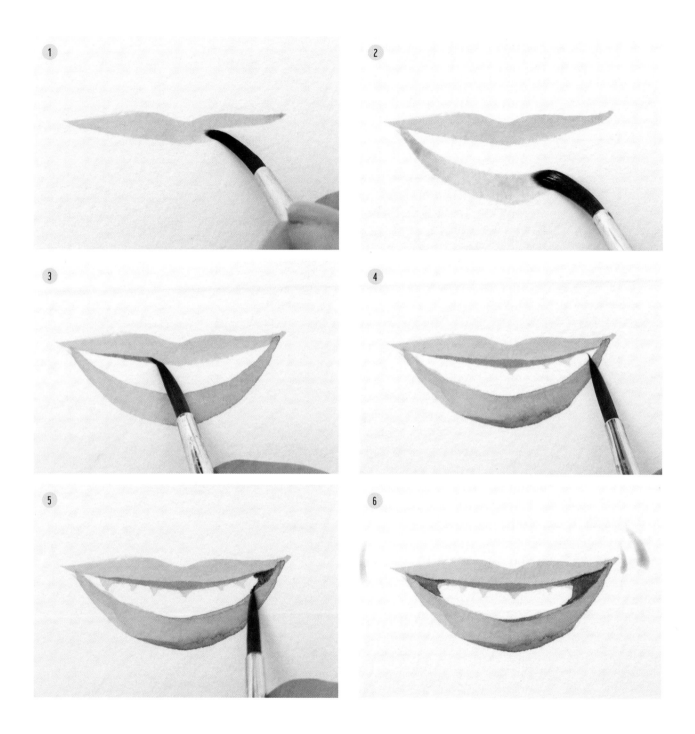

PAINTING EXPRESSIONS

Working from light to dark, you won't take too many chances creating these mouths. We've worked in pencil to define the lines of the mouth, ink marker to play with the different shapes of the mouth, and painted a beautiful smile with watercolor. Combine the myriad of expressions we explored and try your hand with watercolor. Understanding the paint-to-water ratio in watercolor (the means to control the medium) comes with much practice. Be kind to yourself and have fun!

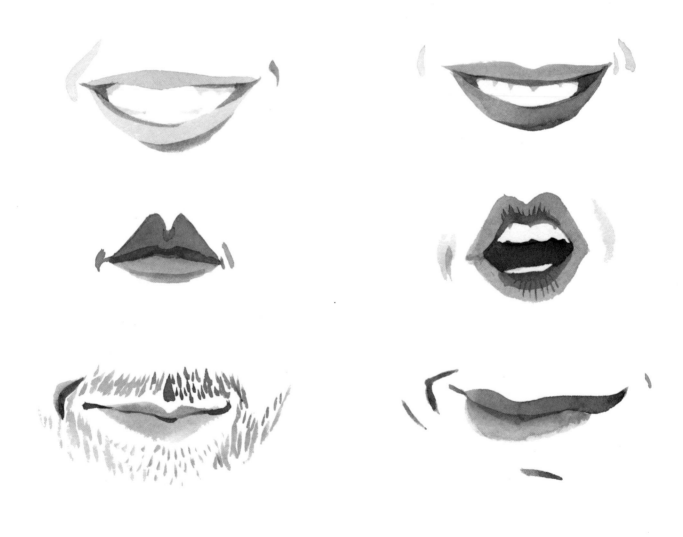

BUILDING A FACE

Revisiting our five faces, we'll take mouths in two steps. For mouths that are fuller and darker, do the upper lip first, then the bottom lip. Mouths that are meant to be kept lighter in tone are also taken in two steps, but the second step adds a few small lines of darker definition to a full mouth. Don't worry about the teeth showing as the flesh color. Add hints of white at the end.

You've watched each part of the face develop—from the shape of the face down to the mouth. Piece by piece we have compiled the face, but these heads do look a bit strange. Let's solve that problem in the next section, which addresses hair.

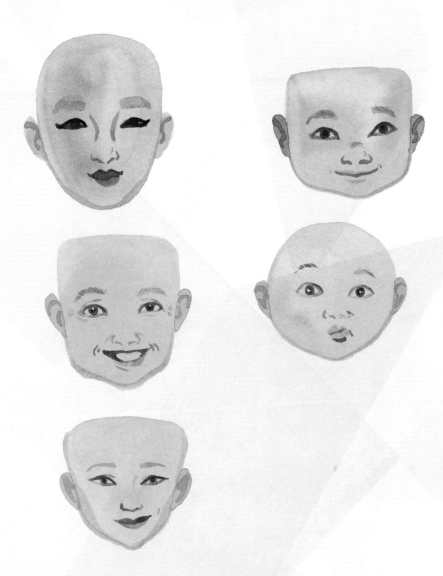

DEPICTING HAIR

Drawing hair can either be a tricky snag that tangles us up or it can be a wild mane in need of taming. Since hairstyles are widely varied and can be quite defining to a person, this section begins to open the door to expressing more personality in our faces.

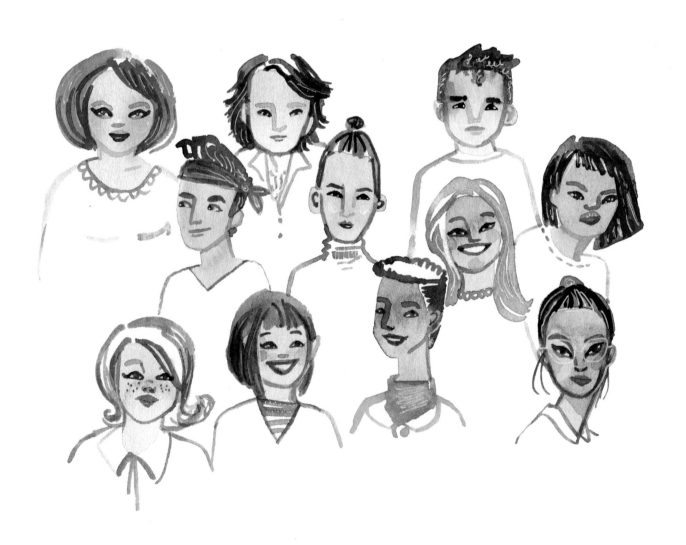

SELECTING AN APPROACH

Previous sections focus on creating *a feature*. Not so with this one—the truth about hair is that no matter how realistic we get, we'll always be depicting hair in some way. Hair is always stylized. It just depends which form of stylization or level of simplicity you choose.

Blockhead

Just as we discussed simplifying the face, consider this portion with a similar slant. The most simplified hair (if present at all) is just a block of color. This may sound bizarre, but it is a common effect, even if many of us might not want to tangle with it. While I don't recommend this super basic way for the approach we take in this book, a block of color can be quite darling.

Painting Tips:

- Use a medium to large brush to fill this area with color.

- A flat brush adds an easy, level cut along the ends.

- Wild, vibrant colors offer a fun twist that plays well with this simple look.

- Take inspiration from midcentury cartoons, which would often maximize flat color to offer a whimsical punch to illustrations.

See page 90 for steps.

A Few Lines

As a next step, paint a block of color to create the outer shape of the hair and then a few descriptive lines to describe its direction. This is a very simple and effective approach. This may seem like a frighteningly easy step, but those little lines add a lot of clarity to the styling of the hair. A bumpy body of hair could be an afro or a mass of curls; a short line of hair on the top may be a buzz cut or a side part. A few lines can instantly settle the question in your viewers' minds.

Painting Tips:

- Use a medium brush to fill an area with color and then use a small brush to paint in lines.

- A line brush has a long body of hairs. These long hairs on the brush make it move gently and in unexpected ways, much like the natural way hairs fall.

- Add interest by using similar but different colors for these lines. Simply mix your main color with a touch of another to create a harmonious shade.

See page 91 for steps.

Your Lines, Your Comb

Rather than creating a mass of hair that is later defined, use your small brush to create the hair as you go. Each brushstroke defines a new strand of hair. Though this may sound daunting, it may not take very long, depending on how the size of your brush relates to the size of the head. In other words, the tip of your brush or marker or pencil may be the width of a chunk of hair rather than each individual strand. This is a fun technique when you're ready to go with the flow of what this hair might look like. You might even feel like a hairstylist! I personally reserve this technique for gray hair (more on that in the section on "Painting Real People"), overly-manicured hair, and very short hair.

Painting Tips:

- Use a brush with a bristle length that reflects the length of hair you're portraying.

- The hair color may appear light since the hair hasn't been filled with a color first, though you are welcome to fill first, of course.

- Gray, white, and salt-and-pepper hair colors work well with this method.

- Other great uses for going strand-by-strand include bangs, baby hairs, and wispy flyaway hairs.

See page 92 for steps.

 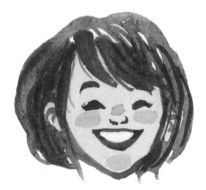 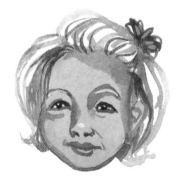

CHOOSING HAIR COLOR

Hair colors seem pretty straightforward, but if you walk the aisle of any store with dye kits you may change your mind. Natural colors range from whites/grays, blonds, auburns, and to the darkest of browns. And yet, within each shade is a small world of shades.

Hair is always naturally multicolored. You may have never dyed your hair or sprouted a first gray, but your hair color is not one single color. This is true even if your hair is jet black. Black hair often accompanies brown hair, browns vary greatly from warm mahoganies to cool sepias, and blond hair can visibly alter with exposure to sunlight. Look at a head of hair under a light, perhaps someone huddled over a book and under a reading lamp, and you'll find a spectrum of tones that shine. Remember this when depicting hair. While it takes some effort in the salon to have a gamut of colors on one head, every head of hair has subtle shifts in hue.

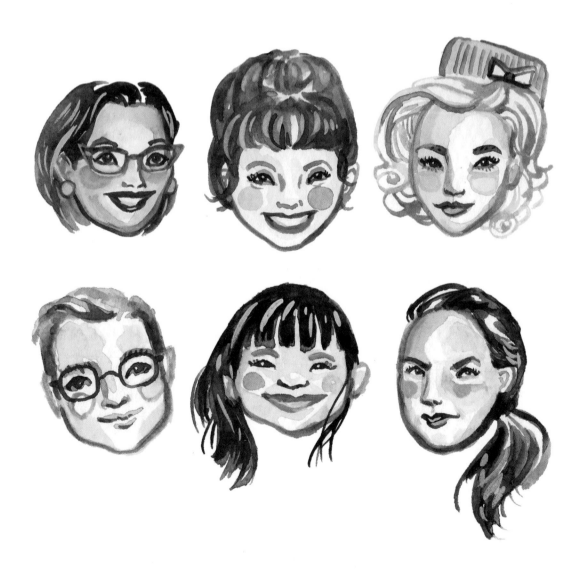

I love to use unexpected colors on hair. It is one of the few places on a face that one can have fun without making a strange creature that may come deathly close to losing its humanity. I tend to veer toward warm, vibrant colors such as violets and maroons. And though I may paint the occasional blue 'do, I've yet to cross the line to green. I find that warm colors work well on people for skin or hair no matter how wild. Violet is a surprisingly versatile color. It can provide a fun twist to dark skin tones or paint the hair of a rebel girl even your mom would enjoy meeting.

Perhaps it's a no-brainer, but painted hair colors follow natural hair color trend perceptions. For instance, if you'd like to explore a lemon-yellow head of hair, it could be misinterpreted as a bad dye job, as would a greenish tint which is often a color that's feared poolside. As an artist, it's best to be aware of trends, but not to follow or dismiss them wholeheartedly. Follow that fun, creative voice within you and temper it only when you feel uncomfortable.

BUILDING A HAIRSTYLE

Looking at a mass of hair can be intimidating—so many strands! Additionally, they're often going every which way. Whenever we feel overwhelmed, we can simplify and break it down.

1 First, break the hairstyle into sections. I'm not asking you to think like a hairstylist necessarily, but simply look at the clusters that make up the hairstyle. They may flow in different directions or they may simply land on different parts of the head.

 The easiest portion to define first is the front. It's the section that most relates to the face as it may land there (as with bangs) but also because it further frames the face. The hair may be pulled back to show the hairline or it may hang over the face, carving out its shape. This front section really sets the tone for the hairstyle.

2 Second, I look at the hair on the sides of the head. It may flow down or curl or curve. Notice that we're really focusing on the sides—not the back hairs that we can often see from the front as with the man on the left. We'll note that section last.

3 The final section may well be those hairs from the back that reveal themselves even when forward facing, be it due to a layered haircut or flowing, long locks. These hairs don't tend to fall in the same way that the side hairs do. They follow a different line as their starting point is also different. I'm including ponytails and buns in this section as well. It's hair that is flowing in a different direction or treated differently than the prior two sections.

4 There may be more hair sections if the hair is highly curled, layered, or complex. On the other hand—as with the lady on the far left—you may not reach a third at all. You may feel more confident beginning with hairstyles like this with fewer differentiations, such as hair that's parted in the middle and falling on either side or a short cut.

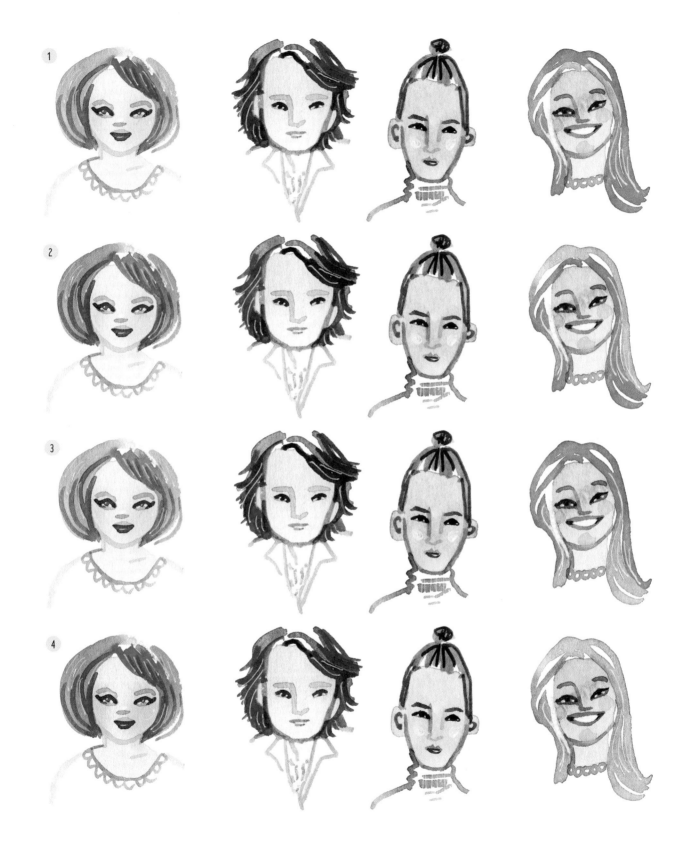

PAINTING HAIR, STEP BY STEP

This section demonstrates the three basic approaches to depicting hair (see pages 83–85).

BLOCKHEAD

1 The simplest way may be the best way, as we make simple shapes to fill in the color of the hair. Use a second tone of color to add interest to your solid shapes.

2 Notice how we can reactivate watercolor to become diluted or semitransparent. One ear is covered by color and one is left exposed for a casual hairdo. The jawline is also easily covered with fresh, watery paint.

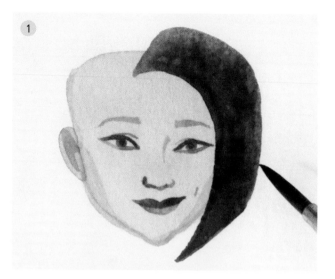

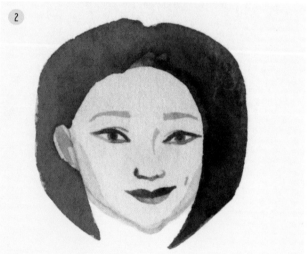

A FEW LINES

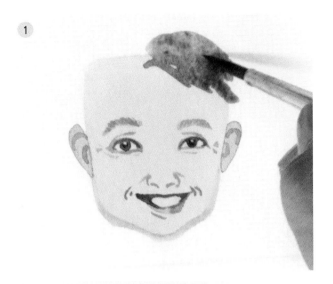

1 The head is covered in hair sections, begin-
ning with the front using a small brush. The
picture shows a size 2. The sides are then
filled in, keeping in mind that our subject has
a side part where the silhouette of the hair
dips down. Though this face is angular, his hair
does not need to follow along the lines.

2 Allow the base hair color to dry fully. If we
start painting while this first layer is still
wet, the lines will expand to blend rather
than define.

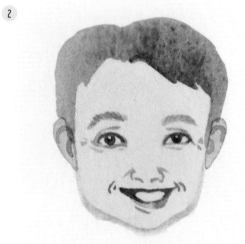

3 Using a smaller brush (size 1 shown) with a
darker shade, make small lines to detail a few
hairs. Describe the direction of the hair, but
don't draw each one.

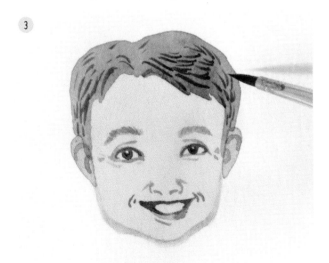

YOUR LINES, YOUR COMB

This technique, which requires a small brush (a size 1 detailer is shown), is a good approach for wispy hairstyles and those moments when you're ready to let the paints take you where they may.

1 I always find it easiest to begin with the front hairs, as they set the tone of the hairstyle. Ears can be covered or avoided to make the hair appear as tied or tucked behind. I chose to give this redhead a layered look since I had the liberty to do so with each wisp of the brush.

2 Potentially three hairstyle layers, each line of hair accrues tens of brushstrokes until the hair appears full.

3 Use two tones or more of the same color to show more depth in your many hairs.

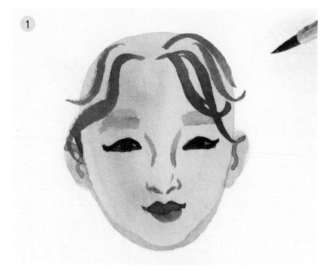

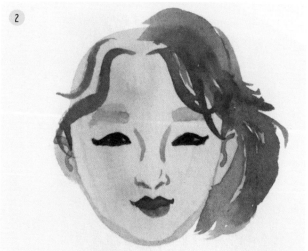

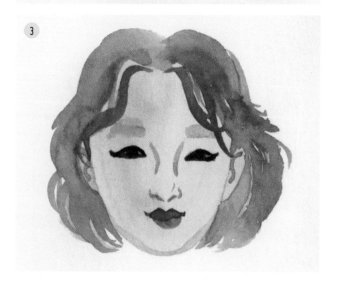

A final touch of white gel pen in the whites of the eyes, a few lines in the hair, the addition of some pearl earrings, and the details of a bandana help to make these five faces feel alive.

The other two heads are outfitted with hairstyles in two of the three approaches already shown. Using an unexpected color is always fun as we have more liberty with hairstyles than, say, skin tones.

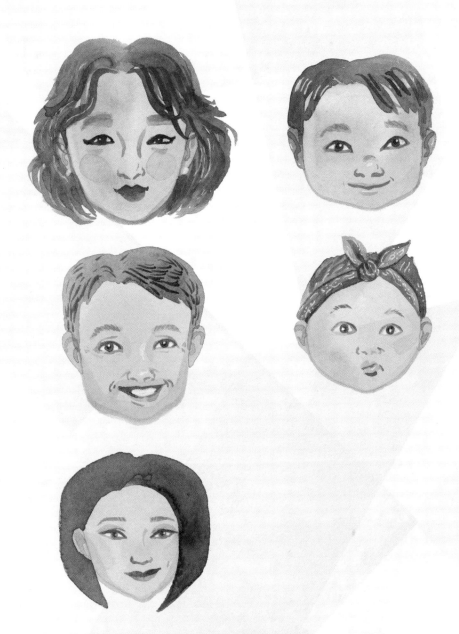

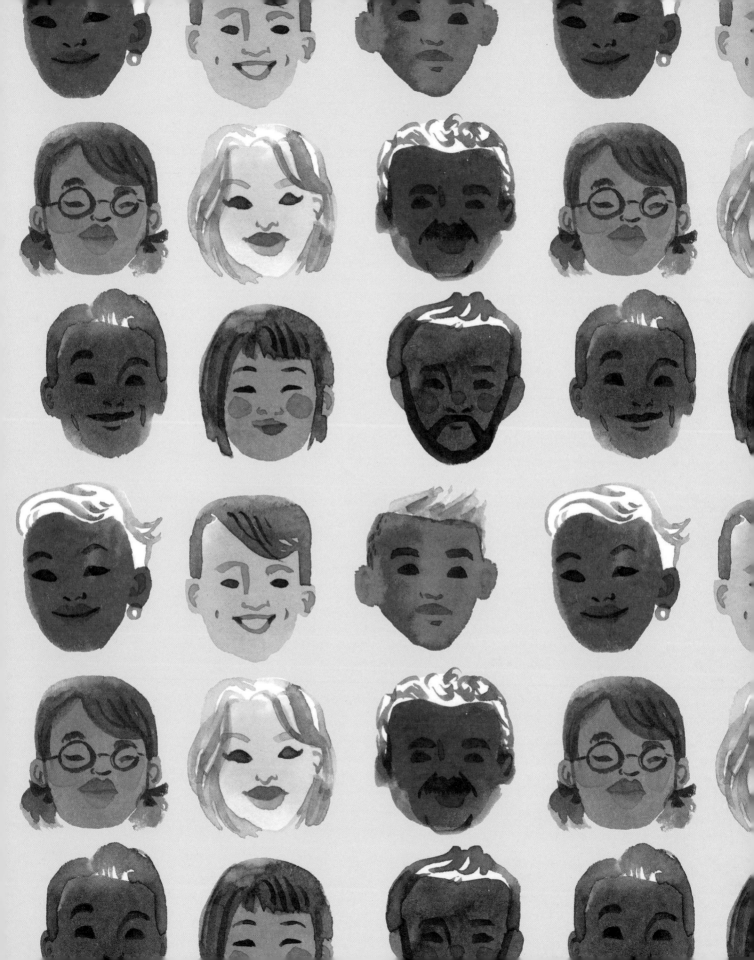

4

PUTTING IT ALL TOGETHER

Whether you jumped into this step-by-step process or just watched it come together as the chapters progressed, what comes next calls for some hands-on work! We get into the motion of putting our techniques into practice over and over, beginning with one color. The hope is that you will become so accustomed to the steps that all you'll need to consider is variety.

PAINTING A MONOCHROME FACE

Now that we understand the composition and features of the face, we'll warm up by using ink in a range of values so we can carefully consider the differences among them before jumping into color.

MORE THAN JUST BLACK

You won't find me working in black and white very often. I want color all the time, every time. But it's important to understand values—the lightness or darkness that our eyes perceive. Even when we're looking at colors, each color represents a value. A pale blue can be lighter than a true orange; value-wise, a light pink is a far cry from fuchsia. Each skin tone, each shadow, each twinkle in the eye has its place along the continuum from light to dark. So it makes sense that we first master painting monochromatically.

The word *monochromatic* literally breaks down to these words: one color. The most accessible and literal of these is black. Black can be as dark as we can possibly go, while its absence is indeed white, and the steps in between make up grayscale, with fewer and fewer drops of black in each step as they fade to white.

We use ink for this section's exercise, which focuses on monochrome work. Ink is permanent and may dry with a slight sheen. What's great about it is that we can work from dark to light and from light to dark without the risk of lifting any of our previous brushstrokes. So when you place a light shadow dreadfully close to a previously painted dark line, that area won't become a giant, dark bruise! You can even give an entire face a nice, light wash to depict a cast shadow and not affect any of the details you've already painted.

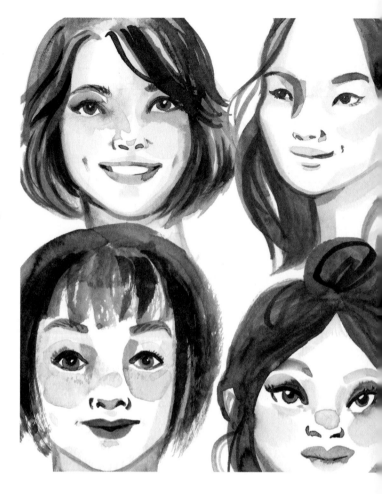

The brush I use throughout the exercise is a no. 6 round sable. The hairs, which are about as long as one-third of an almond, can be used with many mediums, including watercolor, ink, acrylic, and gouache.

PREPARING YOUR PALETTE

1. Pour black India ink into three wells of a palette in these increments: three drops in the first, two drops in the second, and one drop in the last.

2. With an eyedropper, add three drops of water to each well.

3. Drop water into two other wells. One will be tainted with your dirty brush (it will have some ink traces on it by the time we get to this step). The last will be the clearest water, reserved for very light washes if needed.

4. Test the value of each well by painting a small sample of each. Be sure to clean your brush between each step.

MONOCHROME FACE IN INK

1 **Draw Proportion Lines and Features in Pencil.** Be aware that pencil lines left under ink washes, however light, cannot be erased once finished. Nonetheless, these light outlines will serve as a reassuring roadmap, particularly when working in a permanent medium that brings no eraser with it!

2 **Full Black.** In this method, we work from dark to light, which gives the finished piece strong contrast. I also find it comforting to start by focusing on the darkest features. As we learned on page 30, those areas with the darkest values are what our eyes register as most important. Placing the most important features first grants us a little peace of mind, and when creating artwork, peace of mind welcomes mental space for play and creativity.

3 **Darks.** As we apply the next-darkest values in this step, our face really starts to take shape. All the face's most important features are laid in—eyebrows, eyes, nose, and mouth.

In the hair, notice the texture that can be achieved with a brush that has lost most of its moisture. Drybrush techniques are great for adding visual interest and small areas of contrast within a larger area.

With all the boldest features painted, we could stop here. This approach, which focuses on the face's essentials, feels simple and sweet. The steps that follow add more definition, subtle shadows and hints of gray that in this example stand in for touches of color and help give the face more dimension.

4 **Medium Values.** Our medium-light ink, the third on our palette, is the primary source of shadows on the face. Be sure to use a clean brush to avoid leaving dark, unwanted blotches. Begin with the darkest of shadows: those cast by the bridge of the nose and the bottom or underside of the nose. Other shadows mark the sides of the face, making it appear round. Subtle shadows help frame the mouth, with a hint of expression on either corner and above the chin.

5 **Light Values.** Dip your well-used brush in the fourth well, reserved with only water. This will create a very light tone. Lightly paint the eyelids and then add a bit more shadow on either side of the nasal canal and under the eyebrows. Paint details such as freckles, dimples, and the cleft above the upper lip.

6 **Final Touches.** Our last step takes us back to where we started: back to black! With all the values set, we'll boost the richest darks with small touches of contrast—a little black ink in the pupil and eyeliner, some defining strokes for the hair, and small details to make our face feel finished.

7 **Finishing the Face.** The neck with a cast shadow (painted with the step 4 value) and a hint of decorative stitching is all she needs to feel grounded. Both wet brush and drybrush techniques were used in the hair; the top areas show off the ink's bleed, while the ends show the paper's texture.

In the next activity, we'll exchange the range of grays for bold, quick lines.

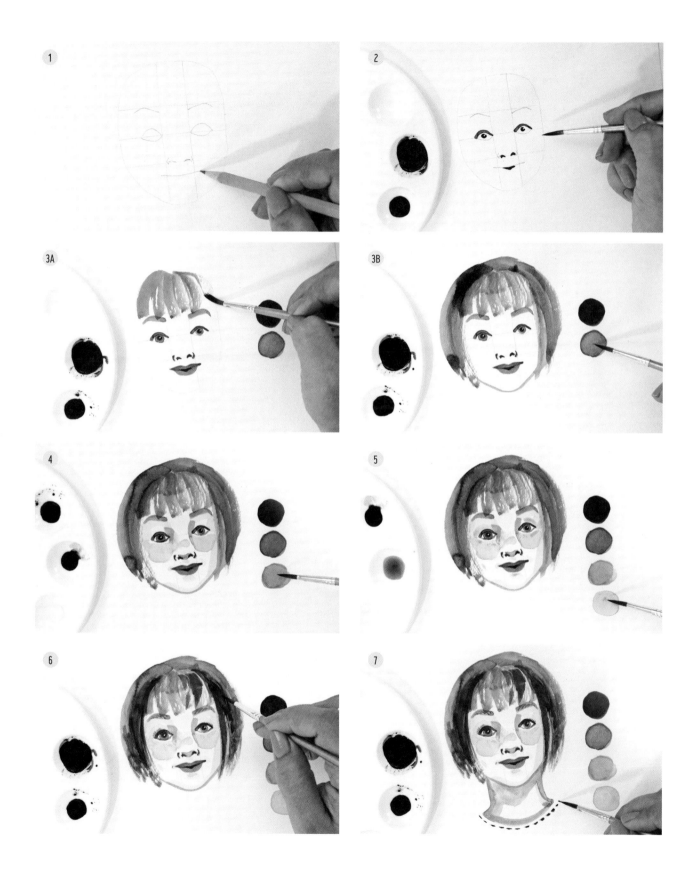

DRAWING WITH A BRUSH MARKER

Now, we're trading our brush and fluid ink for a handy brush marker. Brush markers are the versatile cross between a brush that's loaded with ink and a portable marker. Instead of having a felt tip, brush markers have hairs or bristles. The body of the marker holds liquid ink that is released slowly into the brush head. A squeeze on its ink compartment releases more ink if so desired.

I use the Pentel Art Brush Pen. It's become quite a staple, in my to-go bag and in my work. The ink is permanent, but I wouldn't trust it with heavy washes. I really like the texture the rough ends of the brush marker leave, particularly the older the marker gets.

1 **Value Swatch.** Create a swatch of varying darkness to understand its range. Squeeze the inkwell for a wet, dark look. Apply less pressure for a scratchy feel. Lay the marker so it's almost parallel to the paper and then draw the edge of your circle by scraping it with the top end of the nib.

2 **Rough Sketch and Proportion Gridlines.** You can erase lines after sketching your face, so don't be fussy about the lines and making a great drawing—that's yet to come. Notice how my penciled face doesn't look much like my final drawing.

3 **Outline and Features.** I always like to begin in one of two places: with the face's most prominent features (in this case, the eyebrows) or with the outline of the face shape. Notice how I didn't place the bottom eyeline right away. I draw in the parts that feel essential to this person and then give myself the liberty to decide to add more later on.

4 **Hair.** The brush marker smooshes down as it colors in the hair with very little ink left on the brush. This creates a rugged hairstyle with lots of gaps of white that appear as shine and texture.

5 **Finished Face.** Losing the myriad gray tones made this face much simpler and thus a touch cartoon-like. When you can only work with the black of the marker line and the white of the paper, the fewer strokes, the better. Consider only the darkest darks.

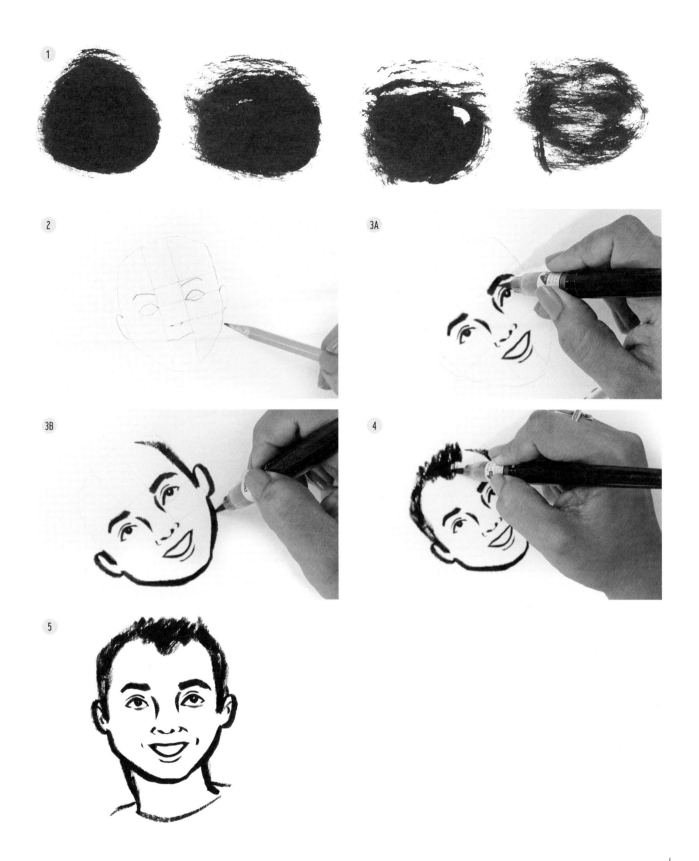

NATURAL SKIN TONES

Certain colors are exclusively for skin tones while some colors will never work. If you're interested in working in watercolor, I'll discuss the paints and brushes that I use to make natural-looking flesh tones, including how I mix pigments with water to get the right shades. I'll also explain how to use a hint of color to suggest shadows and create more natural-looking expressions.

Skin tones can be very specific and somewhat elusive. You won't find skin tones in your average set of markers or crayons, even in their extensive sets, and few mediums have premixed colors that suit skin tones. Though you can find these colors, in this chapter, we first learn to mix and create them so that when you're ready to hunt the perfect color, you'll know how to make it or know exactly what you're looking for. We stick to fluid mediums that mix easily and smoothly. Watercolor is an obvious choice, but these principles can be applied to gouache, acrylic, and other water-based paints.

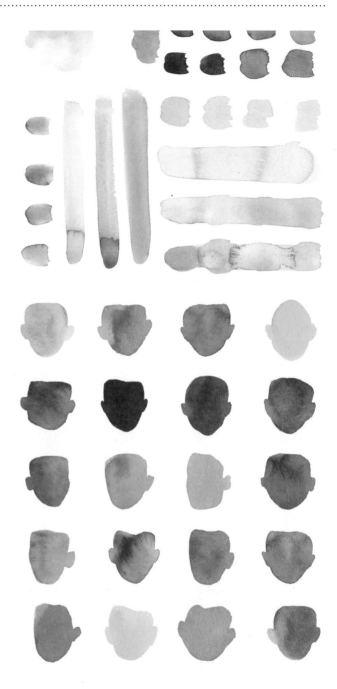

QUICK COLOR GUIDE

Here are some quick points to bookmark for when you're perplexed by color or ready to further push your palette.

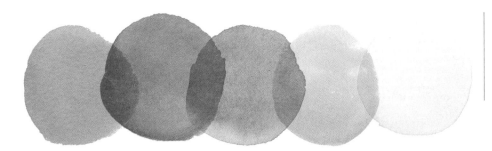

Warm colors are your safest bet when working with facial colors. All colors can be generalized into one of two camps: warm and cool. Warm colors include red, orange, yellow, and variations thereof.

Stay light and build up. It can be difficult to make your values lighter when you've gone too dark. Spare yourself some grief and lean toward the fair side. You can achieve darker skin tones gradually.

Resist relying on black for shadows. We would be hard-pressed to find the color black in the shadows of faces in our pictures if we were to zoom in. We would likely find a dark brown or a color more like burgundy instead.

THE POWER OF COLOR

You don't have to talk to me long to know that I'm an avid lover of color. I enjoy using it in high vibrancy with the occasional twist. Color is a powerful tool, offering us its wide range of power to depict what currently is and impart what could be. Color plays a lovely role in creating delightful faces. Let's consider what color can offer to painted faces.

Realism. Colors help convince us that what we're looking at is real. Great artists that can capture subtle shifts in value and even incredibly subtle hints in varying colors have the power to make us think we have a true person staring back at us. While a portrait drawn in grayscale with pencil may be very convincing and lifelike, it's color that breathes life.

Mood. Colors can both illustrate a mood and impart a mood upon us. Calming blues, energizing oranges, passionate reds, and mysterious violets hold their impact even upon faces. But a blue face? Dark or unique lighting can make faces appear as different colors. Think about looking at your friend's face in the car when the brake lights of another car cast a red glow on their face. Brake light or not, seeing that red on a face sets the stage for a story that the viewer can fill in.

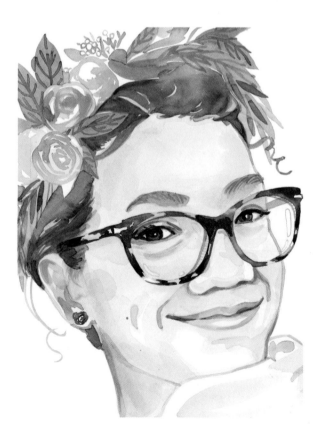

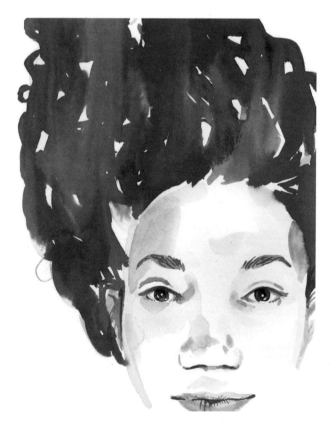

Expression & Whimsy. The Cubist Movement (think Picasso) replaced the complexities of faces with colors—simple faces, brilliant colors, and modern expression. The Impressionist Movement (think Van Gogh) employed color to explore the effects of lighting while forcing the eye to mix vibrant colors. These are just two of the many movements that employ color as a base point in their entire approach to creating art. These colors make statements of expression or whimsy rather than statements of facts.

In This Chapter. We teeter on the edge of realism and whimsy. We don't want to be so adventurous as to create a sick-looking face, but we also want to enjoy the wonders of colorful expression. The colors proposed in this book are a slight version of reality with a look at natural skin tones that pack a punch. We first learn how to mix colors and the most important ones to reach for first.

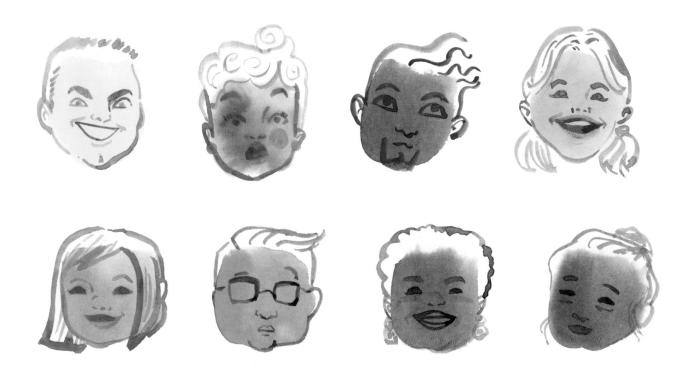

COLORS TO REACH FOR

While songs may want to describe us as red, yellow, black, and white, a better substitution might be pink, ochre, brown, and white (with a hint of any of the three mentioned). We have either reddish or yellow undertones with varying degrees of darkness or pigmentation. Mixing these while exploring the lightness and darkness of each gives you a full arsenal of skin tones. The list from such color combinations may not make for a catchy tune, but nonetheless, reach for these colors for convincing and lovely skin tones.

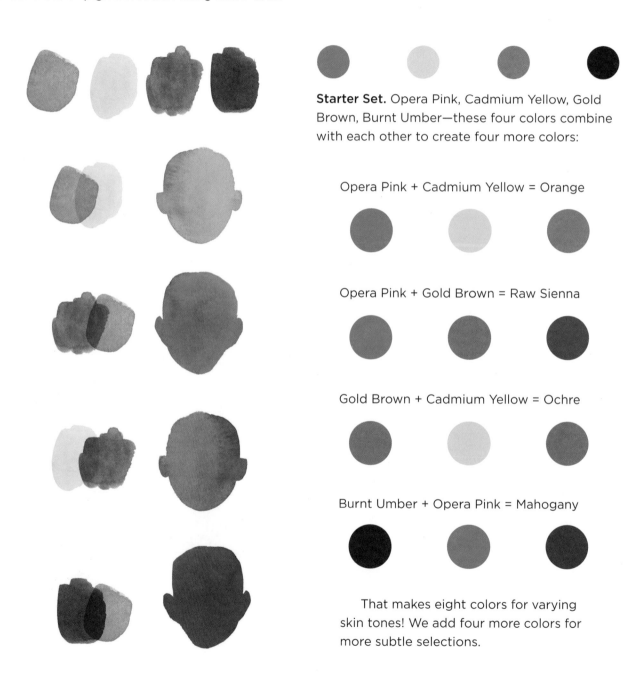

Starter Set. Opera Pink, Cadmium Yellow, Gold Brown, Burnt Umber—these four colors combine with each other to create four more colors:

Opera Pink + Cadmium Yellow = Orange

Opera Pink + Gold Brown = Raw Sienna

Gold Brown + Cadmium Yellow = Ochre

Burnt Umber + Opera Pink = Mahogany

That makes eight colors for varying skin tones! We add four more colors for more subtle selections.

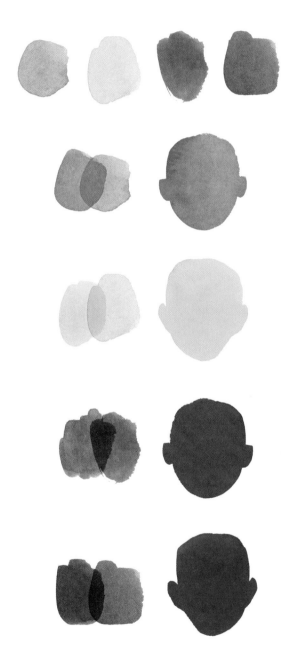

Add Another Round. Rose Red, Chinese White, Van Dyke Brown, Light Red—these four colors combine with each other to create four more colors:

Opera Pink + Rose Red = Coral

Cadmium Yellow + Chinese White = Light Ochre

Gold Brown + Van Dyke Brown = Sepia

Opera Pink + Light Red = Perylene Maroon

We now have a dozen colors that we can vary in intensity by adding more water. This amounts to myriad tints and shades.

A Touch of White. Finally, add a touch of white. We have used watercolor white, but it is a color on its own. Adding a pure, thick white opens the door to a myriad of pastels that can't be concocted with watercolor alone. The change in consistency not only changes the feel of the paint, but also the feel of the color. The matte, flat color blends and becomes an altogether different color choice that takes our warm colors and makes them into cool pastels. You may choose acrylic ink, gouache, pen white, Copic Opaque White, or white ink, but it must be fluid and water-based.

My experiments (below) came to a total of twenty-four colors plus this beautifully muddy violet hue created with all the colors combined. Color mixing is a fantastic form of discovery!

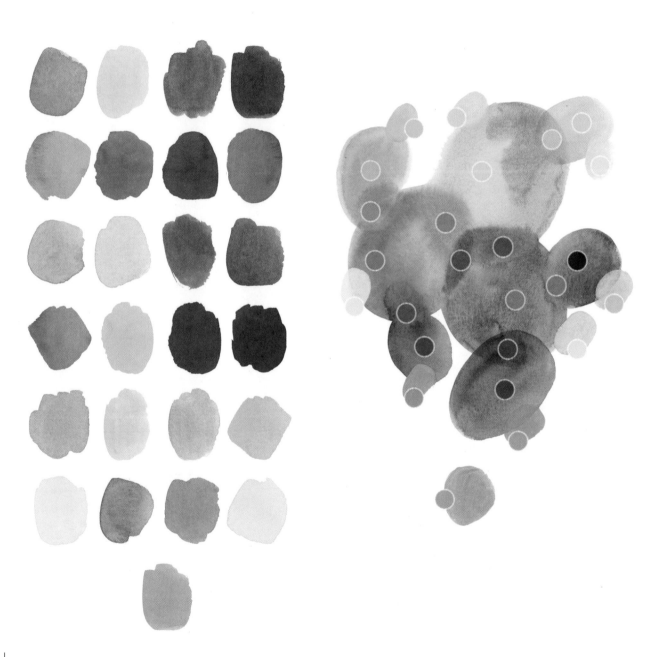

READY-TO-GO SKIN TONES

Mixing colors is fun, but most of us don't want to cook up custom colors every day. "Tube," or premixed, colors fill the need of offering a variety of colors "straight out of the tube." However, I'm excited to introduce you to paints that don't come from a tube. These are a fantastic way to get mobile with your paints.

These paint sheets are flat, thick sheets that won't spill in your bag. High quality watercolor paint is applied heavily to these papers and is easily activated with a wet paintbrush. Their names are stamped to the back, which show what the color looks like when painted.

‣ **MOBILE.** I paint on the go constantly and always have my supplies in my purse in case I'm caught waiting in line or have a few minutes to process an inspiring view. All I need is to stash a few of these paints in my sketchbook and grab a water brush. That's it—making this art tote bag equivalent to the old sketchbook and pencil, but with the advantage of carrying a rainbow of colors that are ready to use inside. The paint papers dry quickly, and I can stash them in my bag.

‣ **SATURATED.** Typically, when brands advertise paints as great travelers, their colors fail. Watercolors may prove to be waxy or chalky, leaving behind pigmentation. Not so with these paints. The colors are so intense that I often find an area with a highly-pigmented subject before working on a lighter area such as a face. The paints are a good investment because you could easily make the examples you see here darker.

Peerless Papers and I have worked together to create a set of skin tones hand-picked by me. The colors shown here are part of the Expressive Little Faces Skin Tones Set. As with all their products, each is nontoxic, transparent, self-blending, and handmade in Wisconsin, in the USA.

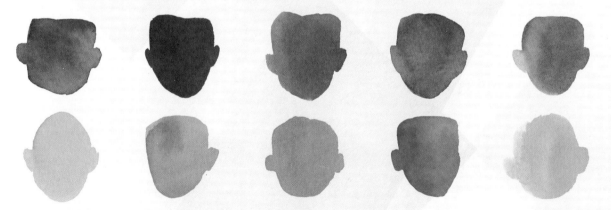

Top row: Warm Sepia, Nectar, Heliotrope, Makeup, Yellow Ochre
Bottom row: Cadmium Yellow, Flesh Tint, Blush Rose Pink, Lip Smackin' Pink, Carnation Pink

FACES IN FULL COLOR

It's time to walk you through the process of compiling each feature and adding detail and lines to finalize personality and expression. Key elements in details are line quality (how different thicknesses can suggest different ethnicities and genders) and artistic styling to put a personal spin on your creations.

COLORING WHAT YOU'VE LEARNED

This is exciting. You're likely feeling very ready to use those beautiful shades of various skin tones and plaster them all over your well-placed proportions. I'm honored to guide you through this section, where we put it all together in full-color grandeur.

If we were to collect all we've covered in prior chapters, it would look like this. Here are the questions we'd ask and answer each step of the way. We begin with larger, basic questions and get more and more specific as we go.

Establishing the Face

1 **Skin Tone Color.** Dark, light, red, or yellow undertone?

2 **Gender.** Face shapes take a different look when male or female.

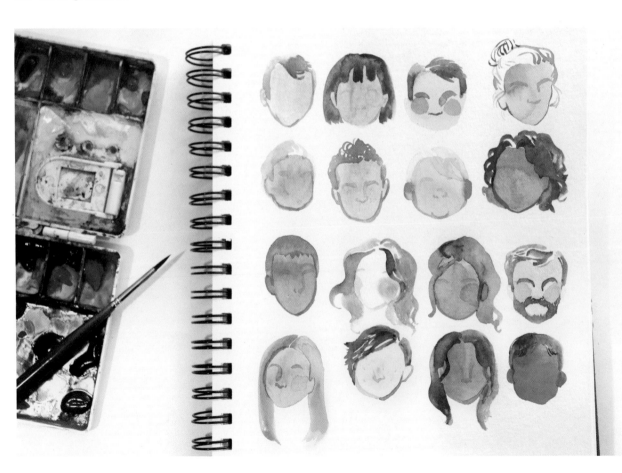

3 **Face Shape.** Round, oval, square, rectangular, or heart-shaped/triangular?

4 **Hairline.** Rounded, peeked, rounded, or inverted corners?

5 **Chin.** Pointy, blocky, distinguished, or rounded?

6 **Ears.** Large or small, protruding, dangling, or attached?

7 **Neck.** Wide or long?

Selecting Features

8 **Eyebrows.** Full, thin, wide, narrow, arched, or flat?

9 **Nose.** Wide or narrow, pointed upward or downward, rounded or angular?

10 **Cheeks.** Notable or subdued, rounded or angular, high or low?

11 **Eyes.** Large or small, rounded, slanted, angled, hooded, deep, wide-set, full of lashes, or portraying expression?

12 **Mouth.** Full or thin, wide or narrow, equally full on top and bottom or not, deep "V" in the center, smile lines, open or shut?

13 **Hair.** Short or long, full or thin, straight or curly, smooth or crimped? What about the hair color—one or several?

The following elements are explained in following sections, but we'll skip ahead a bit for the sake of creating a complete face. You can get your feet wet with how to add personality to your first face and then discover more ideas to broaden diversity in your faces.

Adding Personality

14 **Facial Details.** Dimples, moles, freckles, or facial hair?

15 **Facial Markings.** Ceremonial markings or tattoos?

16 **Facial Accessories.** Eyewear?

17 **Hair Accessories.** Flowers, clips, bandanas, headdresses, hats, or headscarves?

18 **Neck Accessories.** Scarves or neckties?

19 **Hints of Clothing.** A shirt collar or a neckline?

20 **Jewelry.** Earrings, necklaces, or piercings?

This list of options may be long, but you can breeze through it as you work, quickly scanning it as you create a unique face. The more options, the better, but avoid overthinking them.

I find that a common best practice is to work on several faces at a time, as you've seen me do repeatedly throughout this book. It forges the opportunity to say "yes" to many of the options you'd like to try while not overdoing one face. It's also a great way to allow your layers to dry when you're working in a fluid medium. When you return to the original face on which you had paused while attending to others, your sense of comparison will help you see your work with fresh eyes throughout the process of creating.

Let's pool our knowledge and answer these questions as we create an expressive little face in full color.

FIRST STEPS:
ESTABLISHING THE FACE

This first round of layers establishes the parameters of our face, laying down the groundwork and play area for more.

1 **Face Shape.** Let's return to our first step and select a face shape. Is it round, oval, square, rectangular, or triangular? Use a large, round-tipped brush but feel free to switch to something smaller to define the edges. Rather than drawing a perfect shape, keep in mind what kind of hairline and jawline this face might have. Pointy, rounded, angular, or blocky lines give a formless shape the characteristics of a real person.

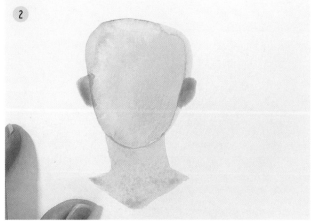

2 **Face Framers.** Switch to a small brush to frame your face shape with ears and a neck. Fill these areas with a slightly darker shade of skin tone. For now, we're just creating flat, filled shapes; we'll add details later. Keep the ears small and remember that their tops extend from the eye line while their bottoms reach the mouth. I extended down from where the jawline begins to angle up on its edges and made a hint of a V-neck neckline to give my face a natural break at the bottom.

SECOND STEPS: ADDING FACIAL FEATURES

Beginning with a slightly darker shade of the skin tone, start placing facial features. Darker, defining lines come after.

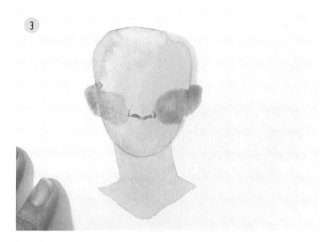

3 **Inner Framework.** Now, we're starting to see our face taking shape as we add eyebrows and a nose. Keep using a darker shade of skin tone. Remember that you can always lay in a darker color later. I like to add rosy cheeks that are often a touch larger and bolder than real life. Add a hint of a shadow along the bridge of the nose to give a touch of definition.

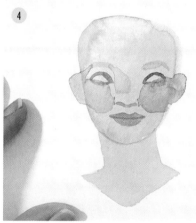

4 **Placing the Eyes and Mouth.** Will you select eyes that are round or angled, small or large? Would you like to venture into a facial expression or emotion? This is the time to make that decision as we select an eye and mouth shape. With the medium flesh tone color, outline the eyes in the shape you'd like. Without loading more color on the brush, place shadows along one side of the face and under the chin.

Select a mouth shape while considering whether the lips are full, thin, have a deep dip, are smiling or not, and so on. I like to make the top and the bottom lips slightly different colors. This gives a hint of shading as the top lip often appears darker, but it's also how I like to add a touch of whimsy.

5 **Adding Hair.** Using a combination of similar colors, place a body of color for whatever hair shape you'd like. Straight hair is the easiest, particularly when using a flat brush, but feel free to hint at the personality with shape and color choice. I chose a straight cut with bangs to highlight the slender neck as it tucks behind.

Add more color to the eyebrows with the same color used for the hair. It's wonderfully easy to define further from here as the shapes of these features are already laid out for us.

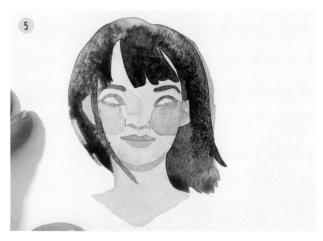

6 **Developing the Eyes.** Pick up your smallest brush or a pointed one with which you feel most comfortable. First, place the circle of your chosen eye color within the eye shape you've painted. Be sure to leave a bit of white sparkle. Second, overlay the eyeline with a darker eye color. This may be an even darker skin tone color or a clean face for a male or a much darker eyeliner if painting a woman with makeup. Add a hint of dark on the corners of the eyes.

7 **Further Defining the Eyes and Mouth.** Once the eye color is dry, add a pupil with black, again being sure to allow white for a twinkle.

A few small lines in the ears painted with the medium skin tone color give them definition. Add further depth to the hair with lines that define a few hairs and their direction. If needed, darken nostrils, the side edges of the nose, under the chin, or any other areas where shadows typically fall.

Finally, add a line to differentiate or cast a shadow between the lips.

Our face is finished! Or is it? Though she is lovely, we'll give her a touch of personality next with both color and white touches.

FINAL STEPS: ADDING PERSONALITY

Our painted face may be a person, yet it needs a couple of simple touches of personality. We can add a flair of charisma with accessories, details, and hints of expression.

8 **Adding Important Details.** Details are easy to overlook but they're often the crucial notes we pick up on at any introduction. Add hair clips, dimples, smile lines, fashion accessories, sunglasses, jewelry, or anything else you can think of to push this face into looking like a real person.

　　A few favorites of mine are shown here, including eyeglasses, freckles, and hints of a collar along the neckline.

9 **Finishing Touches.** Finally, a white gel pen brings back whites covered by watercolor. I like to fill in a bit of the whites of the eyes and add a shine to the hair and the glasses. While easily skipped, this step adds a touch of sparkle to your finished piece.

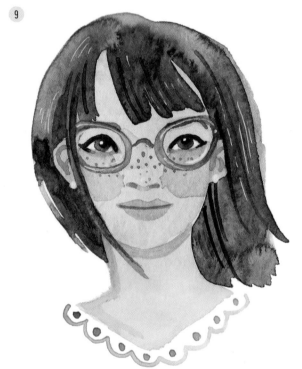

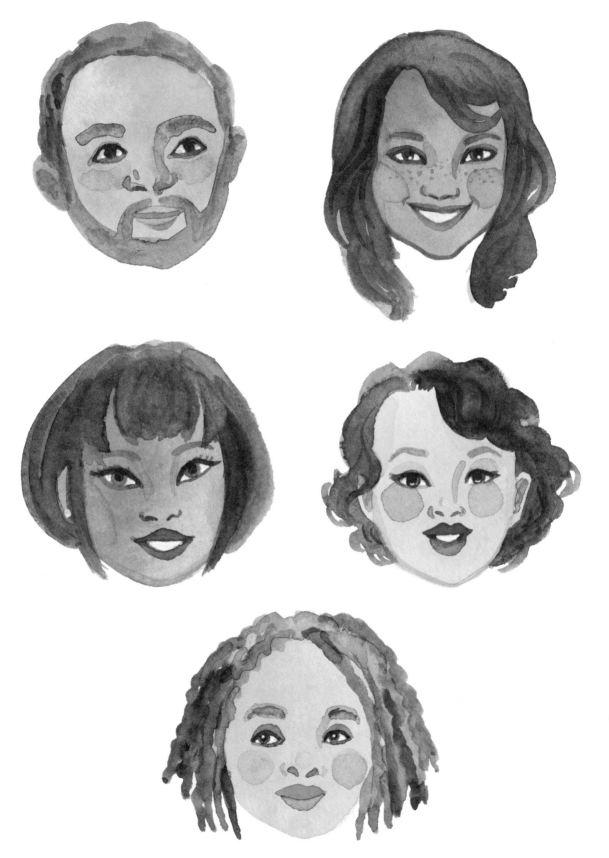

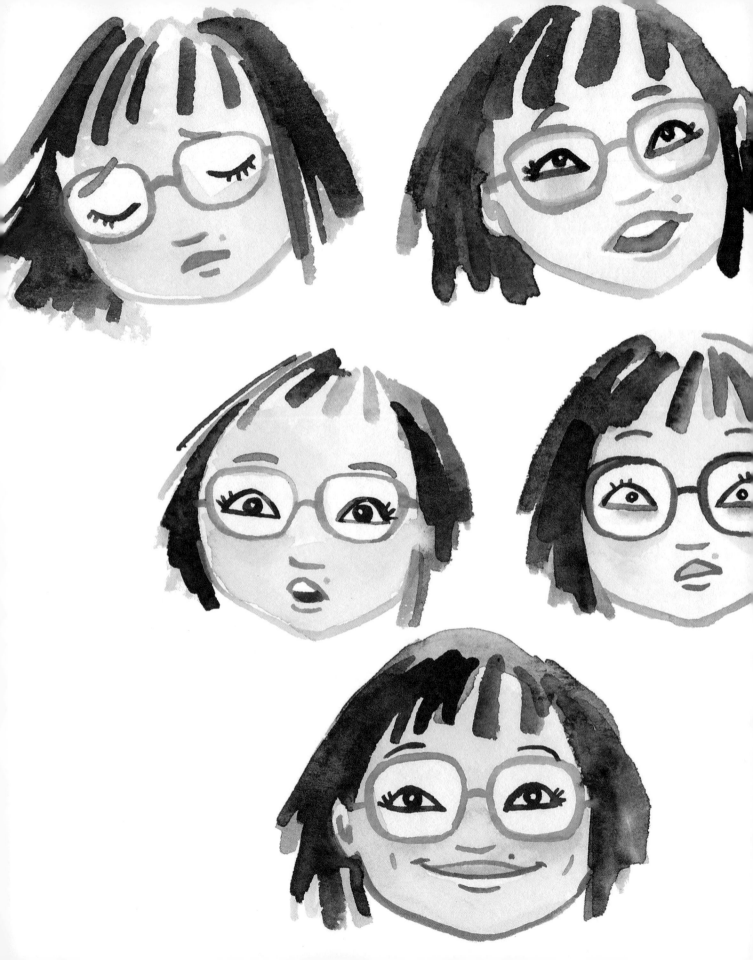

5

PUMPING UP THE PERSONALITY

Creating a robust collection of faces starts with exploration and play. Relishing in a diversity of ethnicities, ages, appearances, subcultures, styles, and apparel will enhance our newfound skills and challenge our limited palettes.

It's easy to get in a rut. You know what you know, and you start to create out of habit. A collection of tiny habits informs much of our creative intuition. This means that we're often left making the same choice over and over when creating art. This is not a bad thing—this is the essence of our personal style. And yet, we can begin to see that the same faces are churning through our wheelhouse, a minute fraction of the wealth of faces out there.

VISUAL DIVERSITY

Enjoying the fruits of diversity—visually, at least—is like having a massive palette full of a wide range of colors, shapes, and motifs. It's like standing at a salad bar with more options than one could begin to enjoy while simultaneously enjoying the thought of all the possibilities.

In order to generate this kind of selection in our minds, we must look outside of our visual neighborhood. A desire to represent the diversity out there means that we get to explore—even if simply within the bounds of our sketchbook. Let's train our eyes to look a little further and gain a gamut of different shades of skin and color as well as a diverse collection of outfits, accessories, makeup, or markings, filling our sketchbook—and perhaps our portfolio—with a variety that proclaims artistic versatility.

A MENU OF OPTIONS

Thus far, we've looked at facial features and asked ourselves questions concerning each. Is it wide or narrow, full or thin, dark or light, round or square, deep or protruding? These questions lead to a group of options, just like the menu on pages 110–111.

This menu of options is a fantastic way to get going on up to a few dozen faces, but we'll soon need even more options. Fortunately for us, we have enough options to make an expansive menu. We can begin by looking at different ethnicities to expand each set.

Ethnicities

Take a trip around the world and you'll see how different faces can be. The handful of eye colors might be the same, but the shapes of those eyes can be phenomenally different. Asian overlapping or "single" eyelids, deep, round eyes in Africa, Pacific natives with a slight slant—variety abounds. What's more with differing ethnicities is the accessories or face markings that are unique to each culture, such as the bindi of a woman from India or the gauged earlobes of Native Americans. As you continue, you'll gather quite an array of embellishments that are both aesthetically interesting and deeply personal.

Take a look at this list—it's nowhere near exhaustive but may spark some inspiration.

- **Head Coverings.** Veil, turban, scarf, hijab, yarmulke.

- **Hair Accessories.** Bobby pins, barrettes, headband, hair ties, flowers, bandana, tiara.

- **Hats.** A classy fedora, an old-fashioned bowler hat, a classic ball cap, a hoodie.

- **Hair Details.** Sideburns, tendrils, baby hairs, fade designs.

- **Facial Hair.** Moustache or beard, whether large and gnarly or trimmed and precise.

- **Face Markings.** Moles, dimples, wrinkles, smile lines, scars, birthmarks, freckles.

- **Ceremonial Markings.** Bindis, piercings, facial tattoos, face painting.

- **Eyewear.** Prescription eyeglasses, sunglasses, monocle, reading glasses, mask.

- **Mouth Accessories.** Toothpicks, hay, cigars, cigarettes, pipes, bubble gum, flowers.

- **Ear Accessories.** Earbuds, headphones, earmuffs.

- **Jewelry.** Earrings, necklaces, headpiece jewelry, face piercings.

You likely have a few ideas swirling about in your mind! Here's a big secret: Inspiration comes with learning.

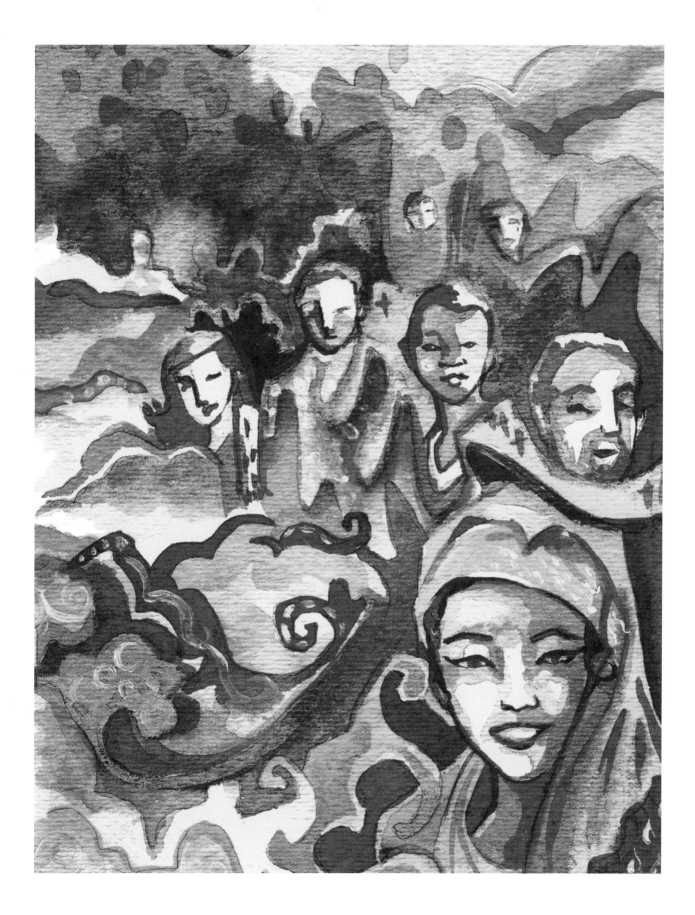

Expressions

Bring your faces to life with emotion. Adding an array of facial expressions multiplies your faces exponentially while making you a better observer and ultimately a better storyteller. You'll write a story all over a painted face.

You've likely seen animators sketch a page like this. It's called a Character Expression Sheet. This page is full of faces that depict one character in myriad expressions as they relate to that character. While a frown may always be a down-turned mouth, it looks different on different faces; mine might look like an exaggerated pout due to my full bottom lip, while yours may look closer to disappointment. Whether you choose to draw one face in several expressions or several faces with one, you can learn a lot by taking the time to fill a page with emotions.

Essential Emotions. Grab a sketchbook and stand in front of a mirror. You are your best model. Choose an emotion from the list below and make that face. Before picking up the pencil to draw, take a hard look at yourself. Notice how your eyes look, how your mouth changes, or what lines may form on your face for a particular expression. You can even trace those lines in the mirror as you study the changes in your reflection. Now, start sketching. Refer to your mirror and "check your answers." You'll likely find yourself making faces at both your paper *and* at your mirror!

Subtle Emotions. Though a drawing of an angry face with all its furious glory may be impressive, the trickiest of facial expressions are the most subtle ones. We are drawing quite simplified faces, which means that you need to mindfully place each line in order to maximize its expressive potential. The *Mona Lisa* may call for a deeper appreciation in you, as her quintessential gaze is so engaging yet difficult to describe.

BASIC EMOTIONS

- Angry
- Crying
- Disgusted
- Excited
- Happy
- In pain
- Laughing
- Nervous
- Scared
- Scheming
- Silly
- Sleepy
- Surprised

SUBTLE EMOTIONS

- Awed
- Bored
- Coy
- Curious
- Disappointed
- Hopeful
- Just okay
- Pensive
- Pleased
- Proud
- Skeptical
- Tired
- Uneasy

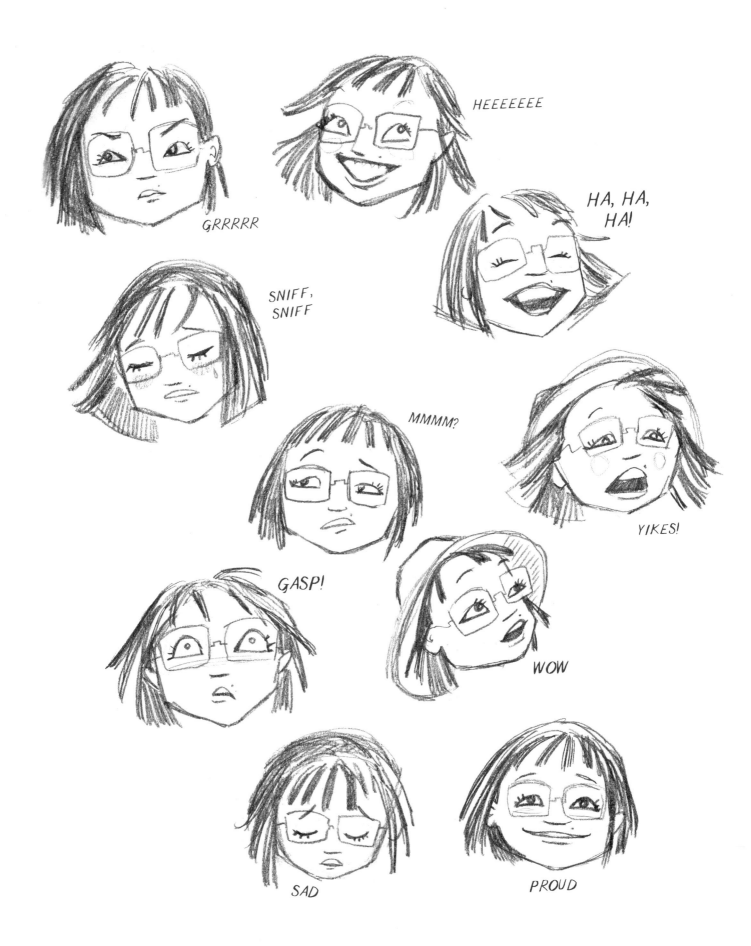

Personality

This section comes after the culmination of all the elements of the face. But a person is not a person without a personality. Personality is our perception of the sum of facial features, ethnicity, personal preferences in appearance, and the way the subject carries their feelings. We can gather so much information with just one face. Not every face you draw or paint will exude personality. In truth, many of the faces you run across feel more like a sentence than a novel. But your faces will represent somebody out there with an attitude and flair all their own. It's up to you to choose the details that will enhance that look. You'll be amazed at how these small cues add up to a big personality.

It's time to pick up some art supplies and see what you can whip up with a few bare face shapes on your page.

From face blobs to each facial feature and down to the white accents on accessories, each face develops a sense of self in a sea of others. My hope is that you will explore the manifold facets of faces and watch them develop before your eyes as you practice and build one element upon the next.

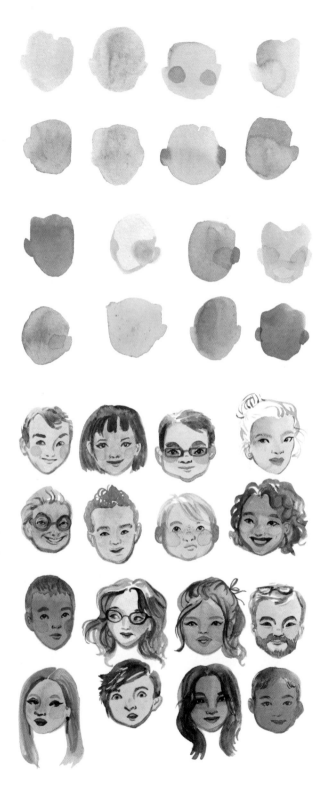

PAINTING REAL PEOPLE

Your newfound prowess at creating expressive little faces may lead to a quite natural urge to draw the people around you. Perhaps you already dabbled with drawing hints of others' faces, making them models if only for one part of the face. Drawing from what really inspires you—those whose semblance strikes you or whose charisma charms you—sets a wonderful challenge for you as an artist. But, it's a mountain well worth climbing.

A SLIGHT SHIFT

We shift our approach just a bit in this section, but we can gather a general sense of direction from what we've learned. We've been gazing at the wide variety of options to find the feature best suited for the personality we're trying to describe. We place each part of the face on the paper or canvas, selecting one by one by our whim. The difference now lies in that selection. We are no longer looking over a menu, but examining a single face. We don't wonder whether we'd like the nose to be wide or narrow; we check to see if it is. The wonderful nuggets of wisdom we've gained by asking constant questions based on description are the same questions we ask now based on observation. We still select a nose, but we look to the subject to answer its queries.

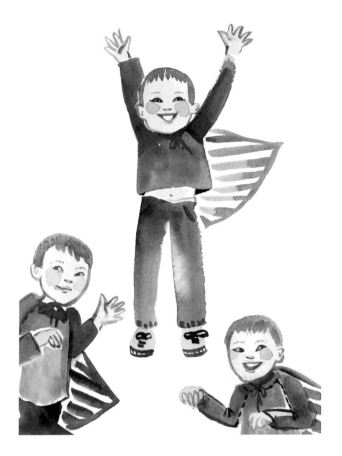

LEARNING TO SEE

We don't look at something very closely until our vision is tested. The blank sheet of paper before us is that test. It can be easy to fall into the assumption that you already know what you're looking at, but as you grow as an artist, you also grow as an observer. Creative people intuitively pick up on their surroundings, noting details others overlook or dismiss. We remember that dimple on only one side of the cheek . . . and if we don't, we will.

Comparing and contrasting comes into play here. Looking at differences jolts us into the reality to which we've become numb. Have you ever traveled to another country and been shocked by what are mundane customs in that place? That's what happens when we note differences. It may be worth comparing two faces when drawing likeness. You can always compare your subject's facial features to your own if no one else is around. Another helpful tool for learning to observe is simply time. Art museums are full of slow gazers because they stare and search for small lines and shadows that don't readily jump

out. We want to look at a piece long enough to notice the effort, the brushstrokes, the unique color treatment or symbolism. We, too, are looking at a piece of divine artwork—a face—singular and full of distinctions. In a fast world, you learn to look, learn to linger, and learn to see.

CAPTURING A LIKENESS (OVER EXACTNESS)

I don't know how caricaturists do it. A stranger sitting there looking back at them with hopeful eyes, their friends or family standing by with suspicious looks. All that pressure! But wait. I do have an idea how they do it (or at least how they manage to whip up the work): they don't aim for exactness. We feel the burden of drawing a face just as we see it, making that person a delightful copy on a plain sheet, but that's simply an unfair strain to put on ourselves. We see people through our own perception and so does the next viewer. I learned this with one of my first portrait commissions. A wife wanted me to paint her husband looking the way she met him: a Californian surfer with only aviators and swim trunks. She wasn't very excited when I gave her the piece. She told the friend who was with her, "It just doesn't look like Frank—I mean, not really." My heart sank. To be fair, it was no Michelangelo, but I kept looking at the photo she gave me and then at the painting between us. I felt a bit of relief when the friend said, "Yes, it does. Just look at this. . . . ," as she pointed to some facial features. Frank's wife nodded and conceded, noting she wished she had given me a different photo reference. It wasn't a shining moment for me, but it taught me that we all see each other differently, particularly the closer we are to the person. It's a beautiful thing! A wife doesn't see her husband's nose as that big, and a son dismisses his mother's large chin. We are more forgiving of those we love.

So we have to make someone look the way they look to everybody? You may ask. Not exactly. We aim to make a painting portray the likeness that others pick up on and agree on. Likeness is the goal, not exactness. But do bear in mind your intended audience. If they're a loved one, go easy on features that are less flattering. Have fun, though, when depicting someone you know your audience despises; they'll love seeing exaggerated, inflated features. Think of that next time you look at a political cartoon!

Likeness, however, is an overarching target. And, it's one within reach. Look for the features that seem to define a person's appearance. Is it their dimples, their facial hair, their hairline? These notable parts are often in the details. A police sketch from several witnesses may not align on major features, but they may have all noticed a suspect's scar, freckles, or teeth.

More often than not, the challenge to depict likeness will be for a face you care about (or for a face your patron cares about). Portraits are a wonderful means to pay homage or respect to someone who is greatly loved. It's as if we want to carry their memory in our hearts by bearing it on paper, seasoned with a lot of time and talent.

Just as we explored the darkest darks in a face and its can't-miss features, explore the face of someone you'd like to draw. I recommend that you draw a friend, but not yourself or a celebrity; we can be quite hard on ourselves and can too quickly compare our work to others when drawing celebrities.

Tips for drawing a likeness:

- Use only one photo reference. Multiple references may seem wise, but they can often confuse as lighting and angles change. The simplest route is usually the best. You can always refer to another photo reference and adjust after you've included the main elements.

- Feel free to "cheat" by manipulating brightness or contrast digitally to more easily detect the darkest darks.

- Take a quick glance and then close your eyes. What do you remember? Make sure you focus on those one to two things.

- Go feature by feature, as we have throughout this book.

· Dad ·

YOUNG AND OLD

Some of the trickiest faces are those of the young and old. Babies and the elderly have slightly different proportions and treatments. Here are some quick tips to create a greater range of faces in your repertoire.

Babies

- When it comes to babies, less is more. Your greatest feat will be to stop "touching" your piece once all the basic features are present.

- In general, a baby's facial features read as rounded because of their added plump.

- Can you say chubby? Even if a baby weighs in on the lower end of the expected percentile scale, those cheeks will still be irresistible!

- Proportions are different on babies. Their eyes are larger, their faces are rounder and less elongated, and their eyebrows are almost nonexistent.

- The tiny noses on babies are not yet well-defined. Therefore, many of them seem to have similar noses.

- The lips are not wide, but narrowly pushed together by their chubby cheeks.

- Baby hair is thin and sparse. Add only a hint of hair and then step back and assess if more is needed.

- A baby won't have a long neck if it is at all notable. Their rounded shoulders begin as the jawline angles upward. Show a hint of a rounded neckline below the face to keep your drawing from looking like the neck was completely omitted.

Children

- Noses are barely developing in children; they won't likely be pointy or large until late adolescence.

- Kids' hairstyles are often simple and shorter, requiring less styling and maintenance. Bangs and ponytails on girls are more common when younger.

- Follow the lip-coloring notes outlined for men. Their rosy puckers aren't bright or deep, but only a small shift from their skin color.

- The eyes tend to look rounder but with a hint of definition as they're growing into their own.

- Fun and excitement just seem to come easier to kids. Facial expressions become quite animated as they exude youthful energy.

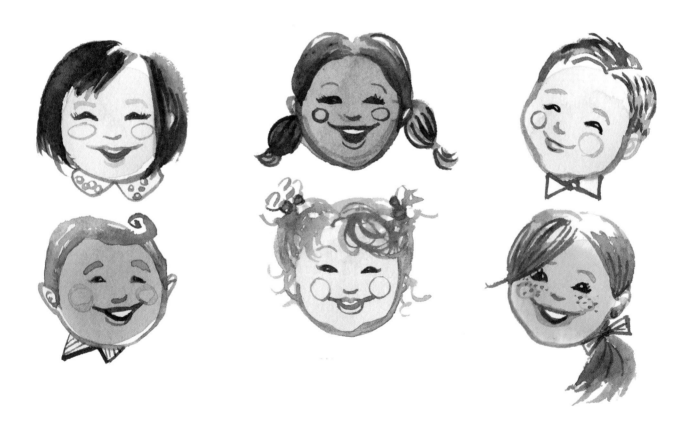

Older Folks

- Ears and noses never stop growing because they're made of cartilage, so you may see large noses or pronounced earlobes.

- It's no secret that hair loss occurs in both males and females. Although it's easy to remember grandpa's bald spot, grandma's hair may not be as full either.

- Wrinkles are tricky. No one should look like they have cracks on their face, so when drawing or painting wrinkles, steer clear of dark colors. Use a subtle color, one shade darker than the skin tone of the face. And if you see twenty wrinkles, only place five. We get the gist! The most notable are smile lines, forehead lines, and "crow's feet" at the edges of the eyes.

- As for eyes, eyelids may droop to appear more like those with single eyelids, curving downward at the outer corners. Eye colors may get lighter as well.

- Upper lips tend to protrude more over the lower lip.

- In general, facial expressions become tamer as we age. The wide eyes of a baby and the excitement of a teenager are not as common. Place an emotion that compliments this special season in life.

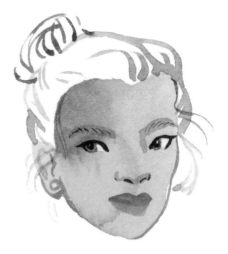

Consider yourself armed with these tips!
Along with what we learned in "Simplifying the
Face," page 27, you'll be able to capture anyone's
likeness.

6

NOT JUST DOODLES

Identify some applicable steps for your newly-heightened face game—sketchbook practice, party invitations, editorial illustrations, repeat patterns, comic books . . . there are so many ways to grow your work!

Painting faces is fun, but giving them a purpose is even better. Your newfound expertise will make you eager to put your skills to work—be it as a fulfilling practice or a professional venture. I want to give you a few ideas to get you rolling while we're still together on this journey. My hope is that you not only discover that painting faces is attainable, but that it's also a viable skill that can take on many different forms. You may even discover a new way of working that you never considered before.

A FACE-INFUSED HOBBY: URBAN SKETCHING

A great way to keep from letting your work grow stale in style and selection of features is to take a little adventure outdoors with your sketchbook. Urban sketching is a fun, popular pastime, particularly for those who commute and pass many faces along the way. It may take a bit of bravery and some quick pencil work as everything is in constant motion and the people you are drawing may not welcome stares. It helps me to relish in that tinge of sneakiness—as if I were going undercover or staking out my surroundings.

A speaker is an easy subject. Listening to someone speak is a fun opportunity to doodle, especially because you might catch a glimpse of a handful of angles for the same facial features. Go easy on yourself and don't critique too harshly. Just keep sketching away. I often find that my page looks more like it has several somewhat similar-looking people on it rather than several sketches of one speaker. It's great practice. It's only by looking that we see differences, and drawing forces us to look intensely at what we presume to be true.

I urge you to get out and get sketching to explore the many skin tones, facial features, and personalities of the faces before you. Be sure to take a sketchbook and travel-friendly tools; leave the messy paints and water cups at home. Begin with a pencil or markers and then branch into loose, painted sketches with a water brush and watercolor sheets as seen in chapter 4.

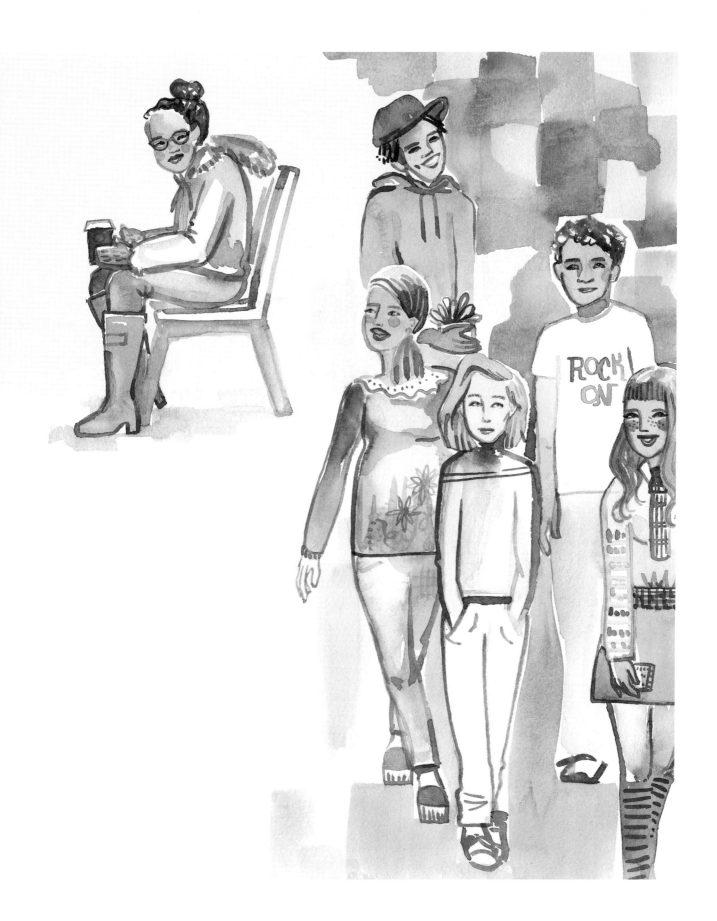

FACE-FOCUSED PROJECTS: PERSONALIZED CARDS & GIFTS

A natural segue from wanting to paint expressive little faces is wanting to paint the faces of loved ones. I've enjoyed painting faces for personalized birthday invitations, baby announcements, holiday greetings, and memorial paintings. It can feel intimidating, but just as we've approached other methods, practice it several times. They may all be the same face, but having several to choose from takes off a lot of the pressure. Do a handful and then give yourself a little time and space before glancing at it again with fresh eyes. After that, all you need to add is a little lettering with a name, greeting, or sentiment.

A fun twist on paper paintings is to make clay gift tags. Everyone will know whose gift it is—or have a fun time guessing! I made these tags with air-dry clay. To get this effect, roll a ball about 1 inch (2.5 cm) in diameter. Then, press it flat to ½ inch (1.3 cm) thickness. Elongate or shape the edges as needed to suit the face shape you have in mind. Use a ballpoint pen to poke a hole near the top through which you can thread the gift tag's ribbon. Allow the clay thumbprints to dry completely overnight. I painted soft skin tones on these with acrylic paint and, once dry, implemented the same steps as shown in this book to paint the faces. If you'd like to play it safe, you may write the person's name on the back to clear any suspicion of who's on the tag.

See pages 125–131 for techniques for drawing real people.

FACE-FILLED WORK

When people understand my job, I get the sense that their heart wells up as if saying, "I knew unicorns were real!" A look of wonder rests on their faces. It's not awe for my work. It's awe for it *being* work. It's as if we're told in storybooks that we could be artists, but the notion loses its merit and is dismissed as sentimentality at some point along the way to adulthood. In truth, we aren't all destined to be creative professionals, and that's quite wonderful, too! I believe we need passion projects, those activities we infuse our energy into freely and without expectation. But for the sake of exposing a few unicorns while exploring our interests, let's consider a few trades in which drawing great faces is a plus or a required skill.

Children's book illustration is a well-known profession where stories often call for faces. If you're interested in becoming a children's book illustrator, practice creating consistent faces of a single character. The character may grow up throughout the story or change expressions, but they must still be easily recognizable as the same person. Animators, storyboarders, comic book artists, and graphic novelists take the skill level up a notch with their consistent drawings that tell the story in even more frames and drawings.

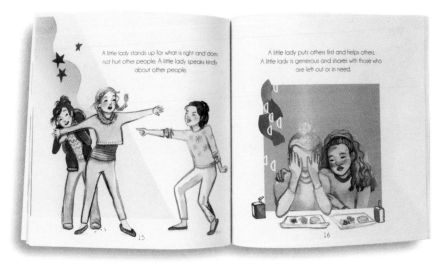

Editorial illustration can often include caricature or portraiture. These are the drawings that you can find in magazines and newspapers outside of the comics section. They help support the content of an article that may be about any subject, including biographies or celebrities.

If your passion is drawing people live, you may become a caricaturist or pair up with law enforcement. Police sketch artists and courtroom artists are always in demand and require someone who is a quick sketcher. You might ease your way into drawing professionally by offering commissioned paintings like those in personalized greetings mentioned earlier in this chapter.

My work is to create art for everyday products that are sold in stores. But you can create much of it on your own. You can upload your art to one of several sites that place your artwork on products and can even create repeat designs with the store's software. A fun project might be to create a pattern of faces as shown below. I used a limited color scheme to make the faces feel more like designs and less like an array of characters. Wouldn't you like to receive a gift with sweet faces on it—perhaps even your own? See page 120 on diversity for inspiration.

PARTING WORDS

I hope you found this to be a worthwhile, exciting journey. The process of learning and creating a variety of faces is rewarding and never-ending. Each face is full of intrigue, its own charisma, and its unique brand. And each one's particular flair will invite you to engage and grow as a creative. We shed intimidation by simplifying, focusing on the can't-miss attributes, the shapes, and the shadows. We learned about proportions and where to place the features. We went piece by piece, placing the elements of the face. And once we were ready to compile all the parts, we went even further, exploring what it might be like to represent both diversity and a real person. Finally, we experimented with a few different directions that our faces could take us.

Once we face our fears about doing them "right," faces are all about fun. Keep painting and growing. Feel free to share your work with us on social media outlets with the hashtag #expressivelittlefaces. I can't wait to see your delightful expressive little faces!

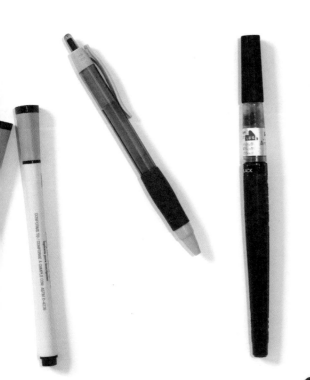

RESORCES

You didn't think I'd leave you one your own, did you? *Drawing and Painting Expressive Little Faces* is a journey that includes as many emotions as it can sprinkle on its sketchbook pages! You may find yourself wanting to learn more or wishing for more inspiration. Here are a few of my favorite touch points.

A Few Favorite Face Artists

Al Hirschfeld

The Line King: The Al Hirschfeld Story is a documentary about this legendary caricaturist who used minimal, fluid lines to relay an incredible amount of personality. Pssst—look out for how he wrote his wife's name "Nina" in most drawings!

Chuck Close

Chuck Close's mesmerizing way of approaching portraiture, using pixilation in photography, is fascinating. *Chuck Close: A Portrait in Progress* is a documentary of this legendary caricaturist. I had the pleasure of seeing his work in New York at the MOMA and on campus at the Savannah College of Art and Design. I dare you to try his method of playing with the relationship between colors and value.

Andy Warhol

This iconic boundary-pusher is no stranger to most of us, but you may have a deeper appreciation for his work as you notice his adeptness at reducing faces to their darkest darks as we did early in this book. Biographies and films abound, but a quick taste of his work can be found online, or take a trip to the Andy Warhol Museum in Pittsburgh, Pennsylvania.

In truth, much of my early inspiration came from animated Disney movies and Archie comic books. Sometimes, copying the Sunday comics may be the boost you need to embrace the simplicity of the face.

Art Supplies

Refer to Chapter 1 on Essential Supplies for a full list but keep the following links handy.

Peerless Transparent Watercolors
Featuring the Expressive Facetones Set, Artist Edition, by Amarilys Henderson
www.peerlesscolorlabs.com

Dr. Ph. Martins Watercolors
Receive a generous 20% discount on your entire purchase by using the code AMARILYS20 at checkout. My favorite skin tone colors include Sunrise Pink, Mahogany, and Indian Yellow of the Radiant Concentrated Watercolor line.
www.docmartins.com

More Instruction from Amarilys

This very book began as one of my many online classes! The *Expressive Little Faces* class is available on skillshare.com/r/amarilys and my website. My classes offer deeper dives into watercolor painting, art, illustration, design, and lettering.

Some favorites include:

- Paint florals with *Modern Watercolor Florals: 3 Ways* and *The A-Z Floral Pathway*

- Explore lettering with any of the styles in the series *Watercolor Lettering*

- Ready to move on to rather different faces? Learn to paint *Watercolor Animal Portraits or Birds.*

Easy access to all of these is found on my website: amarilyshenderson.com. More classes are added regularly.

ACKNOWLEDGMENTS

Every artist has a gaggle of supportive folks who listen to their frustrated bellows, who accept and cheer every step of the way. And there are those who help with the areas we artists often skip over. These people are the stitches that bind a stunning tapestry of creative endeavors.

My Creator: You are responsible for all of the skill, desire, and joy that comes from my art. Every personal painting renaissance came to me through a call to draw closer to God and a deeper discovery of who I am in Jesus. Thank You for all the paths You've forged for me and my art.

Ryan: You listen to me debate the next opportunity and understand the stares across the dinner table when I ponder a project's challenges. You grant me freedom to pursue an unpredictable path that greatly affects you. Thank you for choosing to be excited when it's tiring and supportive when you should be getting a share of the credit. While I've trained you in the need for watercolor rainbows and kitten-topped cupcakes, you've taught me to be a person of principle and devotion.

The Team at Quarto: It's no overstatement that you all made this book possible! Joy, thank you for pausing to talk with me, an artist in a sea of many. Thank you for seeing possibility and partnering in this project! Thank you to Anne and those who brought the book into its visual reality, to Lydia the championer, and Renae for joyfully understanding us artist types.

Mom: I watched you while you finished night school and worked in advertising—you showed me a career in the arts was possible. You steered my passions and have always shown your mom pride. Thank you for joyfully accepting every handmade gift when you deserved better spoiling.

Friends: I may be an introvert with a limited bandwidth for social interaction, but you'd never know it by the wealth of friends I have. Friends that are down for whatever, who ask what I'm working on and support me, who I can text late at night for advice or ideas. Never underestimate the role you play in my life, career, and mental and emotional health.

The Team at Skillshare: I may have been able to create these lessons and thrown them on the internet anywhere, but I'm happy that I chose you. Thank you for your ongoing support and dedication to excellence.

ABOUT THE AUTHOR

Amarilys Henderson is a watercolor illustrator originally from Puerto Rico. She lived in several states during her upbringing, ultimately moving overseas as an adult. With her sketchbook and art supplies always in tow, Amarilys can't remember a time when creativity did not play a regular role in her life. Her path ultimately led her to major in illustration at the Savannah College of Art and Design and begin illustrating in books and publications in 2003.

She has since enjoyed bringing the dynamic vibrancy of watercolor to everyday products, from paper to porcelain as a surface designer and illustrator. Her business, Watercolor Devo, came from her creative renaissance catalyzed by newfound motherhood and refreshed faith. Her creative Christian expressions (coined *watercolor devo's*) drew Amarilys back to the joy of depicting truth, life, and beauty. Her experience as a commercial artist coupled with her welcoming teaching style has opened the way for Amarilys to teach several successful online courses.

You'll find this mom curled up like a cat in her Minnesota studio, lattes and brushes at the ready. See more of her work on amarilyshenderson.com.

INDEX